IMAGES
of America

BROOKLYN

IN THE 1920s

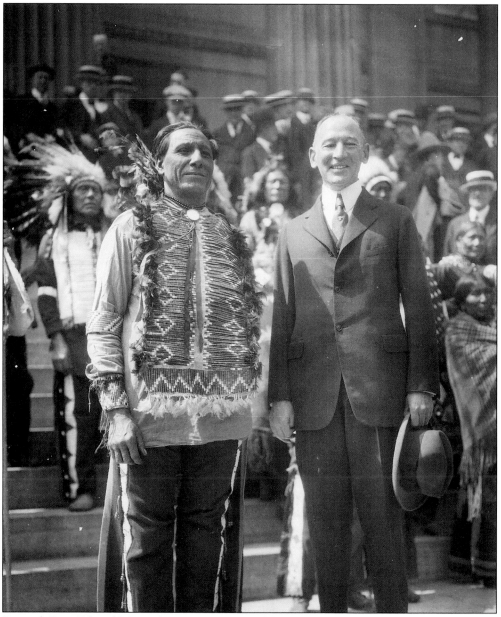

Borough Pres. Edward J. Riegelmann, serving Brooklyn from 1918 to 1924, stands proudly with Chief Lone Eagle of the Sioux tribe in front of Borough Hall at the official opening of the K. of C. Rodeo, June 9, 1924.

Front Cover: Borough Pres. Edward Riegelmann, in the center walking, prepares for the departure of the Scott Modern Caravan on Joralemon Street in front of Borough Hall. The caravan was headed for Buhl, Idaho, on July 28, 1921.

IMAGES
of America

BROOKLYN
IN THE 1920s

Eric J. Ierardi

ARCADIA
PUBLISHING

Copyright © 1998 by Eric J. Ierardi
ISBN 978-0-7385-9005-9

Published by Arcadia Publishing
Charleston, South Carolina

Printed in the United States of America

Library of Congress Catalog Card Number: 98-87141

For all general information contact Arcadia Publishing at:
Telephone 843-853-2070
Fax 843-853-0044
E-mail sales@arcadiapublishing.com
For customer service and orders:
Toll-Free 1-888-313-2665

Visit us on the Internet at www.arcadiapublishing.com

**All photographs are from the private collections of
Eric J. Ierardi and the Gravesend Historical Society.**

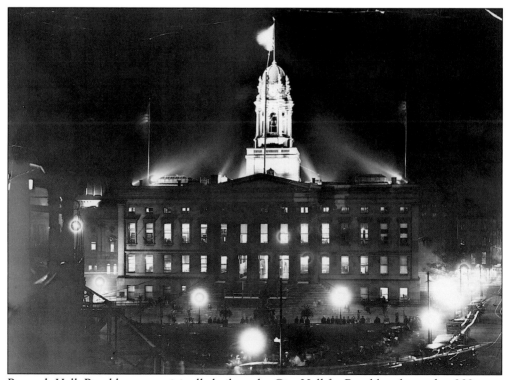

Borough Hall, Brooklyn, was originally built as the City Hall for Brooklyn, located at 209 Joralemon Street. It was built between 1846 and 1851 by the architect Gamaliel King. Here we see the tower lighted for the first time at 9 p.m. on September 15, 1921.

Contents

Introduction 7

1. Brooklyn 9
Adelphi, Bedford Stuyvesant, Boerum Hill, Brooklyn Heights,
Carroll Gardens, Cobble Hill, Columbia Terrace, Crown Heights,
Fort Green, Greenwood Heights, Park Slope, Red Hook, South Brooklyn,
Sunset Park, and Weeksville

2. Bushwick 31
Bushwick, Greenpoint, and Williamsburg

3. Flatbush 43
Broadway Junction, Brownsville, Cypress Hills, East Flatbush, East New York,
Flatbush, Highland Park, Kensington, New Lots, Spring Creek, Starret City,
Wingate, and Winsor Terrace

4. Flatlands 63
Bergen Beach, Canarsie, Flatlands, Midwood, and Mill Basin

5. New Utrecht 83
Bath Beach, Bay Ridge, Bensonhurst, Borough Park, Dyker Heights,
Fort Hamilton, and New Utrecht

6. Gravesend 101
Brighton Beach, Coney Island, Gerritsen Beach, Gravesend Village,
Gunthville, Homecrest, Locust Grove, Madison, Manhattan Beach, Parkville,
Pelican Beach, Plum Beach, Sea Gate, Sheepshead Bay, South Greenfield,
Ulmer Park, Unionville, West Brighton, Woodlawn,
parts of Bath Beach, Bensonhurst, Marine Park, and Midwood

Dedicated to Kenneth R. Zitelli.

In freta dum fluvii current, dum montibus umbrae
Lustrabunt convexa, polus dum sidera pascet,
Semper honos nomenque tuum laudesque manebunt.

While the rivers shall run to the ocean, while the shadows shall move in the mountain valleys, while the sky shall feed the stars, always shall thy honour, and thy name, and thy glory abide.

—Virgil

INTRODUCTION

When Brooklyn was a city, it was known as the City of Churches. Hollywood had its beginnings here. The first monorail in the world and the first transcontinental air flight are just a part of its history. The first major battle of the American Revolution was fought here. Racetracks and places of great entertainment were also pages of its saga. Yes! Brooklyn has its own tale. It began as a small settlement, became a city, swallowed up the surrounding townships, and then died, relinquishing its title as a city to Manhattan.

Perhaps Brooklyn's greatest mistake took place on January 1, 1898, when it turned over a handsome bank account to Manhattan and took second place as a mere borough.

From 1834 until 1898, Brooklyn governed itself as a city. From its inception, Brooklyn was only one of the six original townships that made up its geographical area. Five of these towns were Dutch: Brooklyn, Bushwick, Flatbush, Flatlands, and New Utrecht. The English town of Gravesend made up the sixth. From a simple township, Brooklyn incorporated itself into a thriving metropolis. As the years passed, the other towns annexed themselves to this great "city." By 1896, it was united totally as a city with the final annexation of Flatlands.

This photographic historical presentation hopes to convey what Brooklyn was like during the 1920s, a period of great progress for the Borough of Brooklyn. Sewers were constructed and streets were paved, especially in the southern section of the borough. The book is presented in six chapters, each chapter representing one of the six original towns that incorporated Brooklyn. Many local communities that are known today fall within the boundaries of these original townships.

I hope you enjoy browsing through these pages.

Brooklyn, once a town, then a city, is today made up of many ethnic groups that make Brooklyn a colorful mosaic— "a world in microcosm." If Brooklyn remained a city, it would be America's fourth largest.

I would like to thank E.E. Rutter, who served as the official photographer for the Borough of Brooklyn, whose photographs are used exclusively in this book.

In addition, I would like to thank the following: Hon. Sal Albanese, Sam Amster, Bay Improvement Group, Bay Ridge Historical Society, Bay News, David A. Boody Family, Borough Park Historical Society, *The Brooklyn Eagle*, Brooklyn Historical Society, *Brooklyn Graphic*, Brooklyn Public Library System, *Brooklyn Skyline*, *Brooklyn Spectator*, Hon. Adele Cohen, Hon. William Colton, Dr. Thomas DiMaria, Prof. Louise Donadio, Ralph W. DiBugnara, Joseph Ditta, Dr. Lovis D. Fontana, Esq., Hon. Vito J. Fossela, Steven Ganzell, Frank Giordano,

Aileen R. Golden, Hon. Howard Golden, Joseph Guzzardo, Esq., Dr. John M. Hayes, Mary J. Hirschel, Dennis Holt, Julie Houston, Evan Kapitansky, Prof. Arthur Konop, Nelson Kuperburg, Hon. Seymour P. Lachman, Hon. Howard Lasher, Hon. Sebastian Leone, Marion Lish, I. Donald Nier, Kevin McGovern, Esq., Cav. Aldo H. Mancusi, John Minore, John Musumeci, Comm. Avv. Carl J. Morelli, Michael Nagler, Ellis Nassour, Joan Palisi, Dr. Joseph Palisi, Lynn Rosen, Bione D. Sanchez, Hon. Carmine Santa Maria, Hon. Charles E. Schumer, Joseph Solmo, Hon. Ralph Tarantino, Dr. John J. Tantillo, Robert Ventimiglia, Hon. Donald Weber, Helen Wolf, Paula Young, and Harold Egeln Jr.

Eric J. Ierardi, June 1998

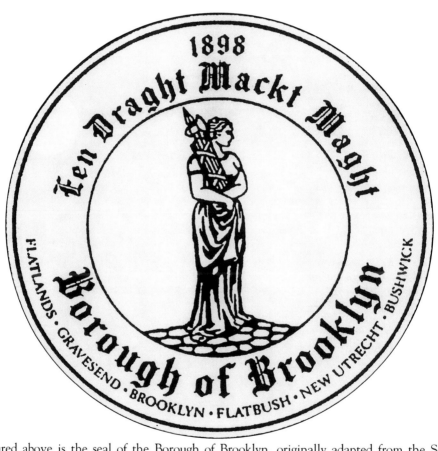

Pictured above is the seal of the Borough of Brooklyn, originally adapted from the Seal of the City of Brooklyn. Brooklyn was in need of an official seal affirming the authorization and authentication of its documents. A seal was sent from Holland depicting the goddess known as Vesta to the Romans and Hestia to the Greeks carrying on her shoulder the fasces and ax. The goddess of the home fire worshipped by the Romans and Greeks represented a connection to the motherland of Holland. The fasces and ax itself were symbolic of "sovereign power." The motto in the seal, "Een Draght Mackt Maght," is often translated to mean, "In Unity There Is Strength." It is literally translated to mean, "Might makes right," which, perhaps, demonstrates Holland's desire for strength and justice.

One

BROOKLYN

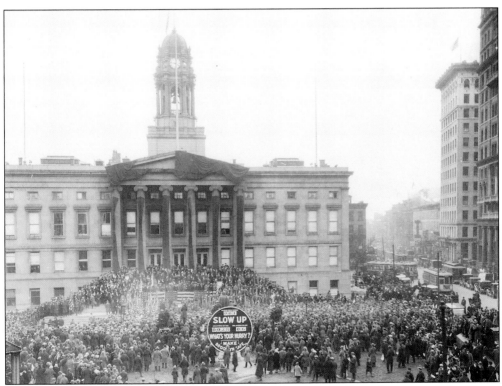

This is a general view of the crowd in front of Borough Hall as they attend the Bonus Demonstration on March 3, 1924. The demonstration campaign encouraged car drivers to slow down and drive more carefully. To the right of the photograph is Court Street.

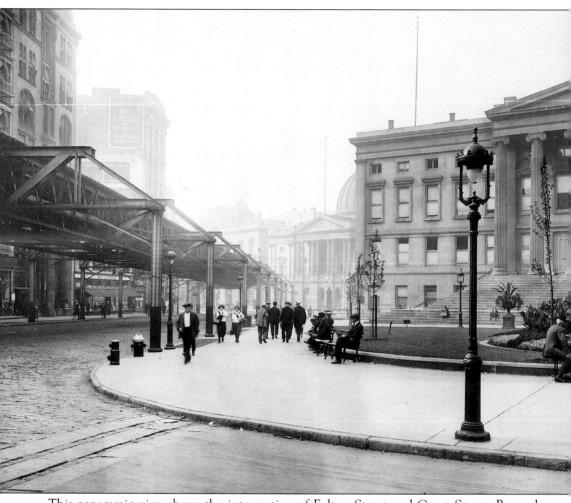

This panoramic view shows the intersection of Fulton Street and Court Street. Borough Hall stands in front. To the left of the photograph is Fulton Street showing the elevated train service. In the rear to the left is the old courthouse. The courthouse was torn down

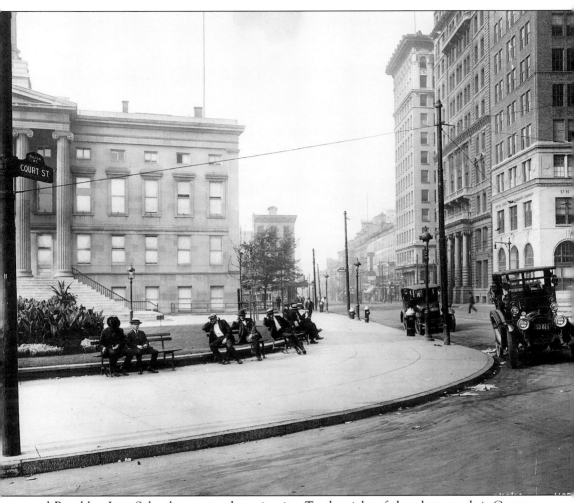

and Brooklyn Law School now stands on its site. To the right of the photograph is Court Street. This photograph was taken on July 17, 1921.

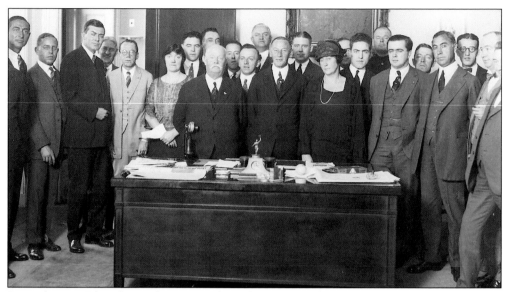

Borough Pres. Edward Riegelmann stands in the center at his desk with his friends and office staff at the notification ceremony held on October 3, 1924.

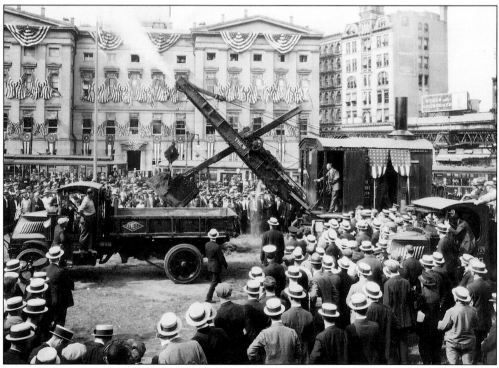

Borough Pres. Riegelmann breaks ground for the erection of the new Municipal Building at Murphy Park, on August 13, 1924. The Park was named for the former mayor of the City of Brooklyn, Henry C. Murphy, who served in 1842. Fulton Street is to the right.

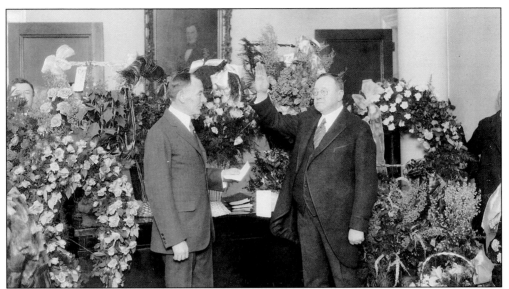

Supreme Court Justice Riegelmann swears in the new borough president of Brooklyn, Joseph A. Guider, on January 1, 1925. Borough President Guider served from 1925 to 1926.

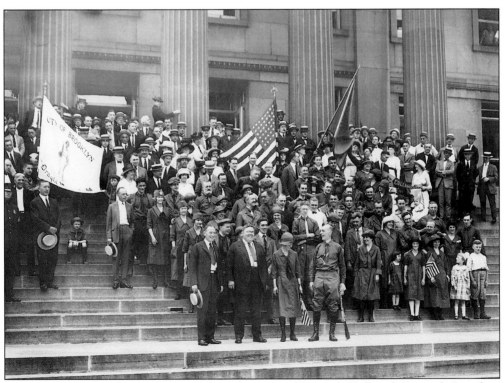

William D. Scott and Mrs. Scott stand on the steps of Borough Hall with Borough President Riegelmann, former Sheriff Daniel J. Griffin, and members of the Scott Modern Caravan just prior to their departure from Brooklyn for Buhl, Idaho, July 28, 1921. Notice the flag of the City of Brooklyn being shown. It had been 23 years since Brooklyn was a city. Were there any regrets they were trying to convey?

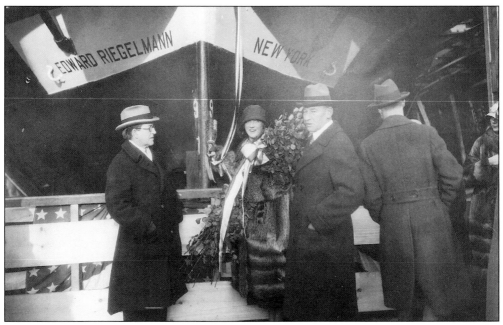

Borough President Riegelmann looks on as Miss Marion Coles is about to christen the *Edward Riegelmann* ferryboat at the Brooklyn Navy Yard on December 27, 1924. The ferry went into service carrying passengers and cars between Staten Island and Brooklyn until November 1964.

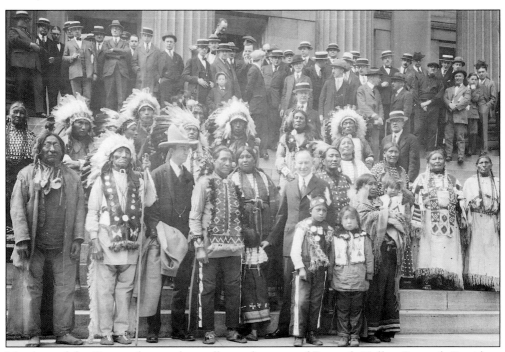

Members of the Sioux tribe stand proudly on the steps of Borough Hall at Borough President Riegelmann's initiation as Big Chief EA-PAUGH-ER, on June 9, 1924.

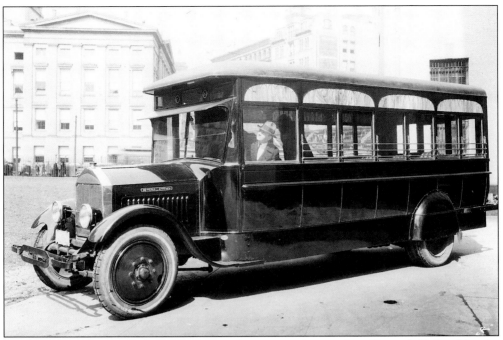

A proposed modern bus for new city lines is demonstrated across from Borough Hall at Murphy Park on March 21, 1924. Notice the gothic design of the stained glass along the top of the bus.

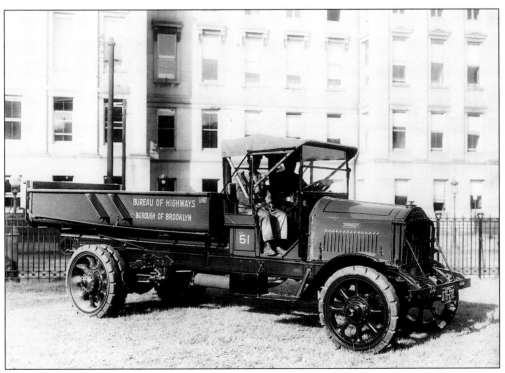

The new motorization of the highway equipment for the Bureau of Highways is shown across from Borough Hall on October 18, 1921.

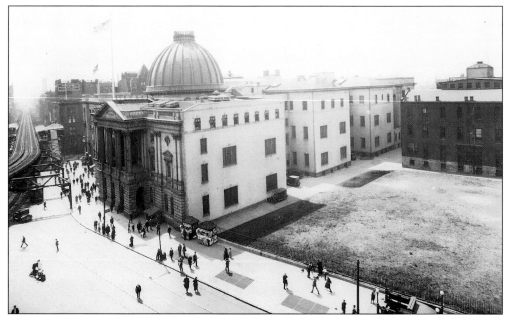

A panoramic view of Murphy Park and the old courthouse is taken from the roof of Borough Hall on May 31, 1924. Today, Brooklyn Law School occupies the site of the old courthouse and the Municipal Building occupies what was once Murphy Park. Fulton Street is to the left.

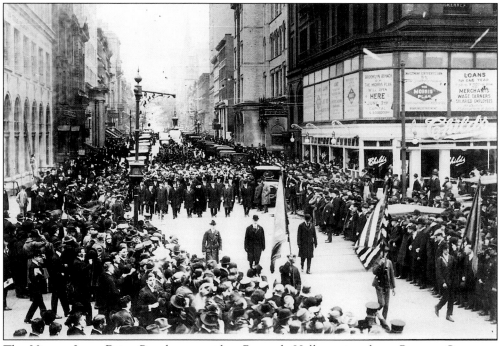

The Victory Loan Drive Parade approaches Borough Hall coming down Remsen Street on May 12, 1919. The Brooklyn Union Gas Company was located to the left in the building with the columns. Today, it the Library of St. Francis College. In the foreground is Court Street.

Pictured above are buildings on the southeast corner of Court and Joralemon Streets on February 3, 1924. Today the Municipal Building occupies the site as well as the Board of Education's 65 Court Street building, which was later to be built to the right of the area in this photograph.

This is the new Children's Court Building located at 111 Schermerhorn Street as it appeared on April 17, 1922.

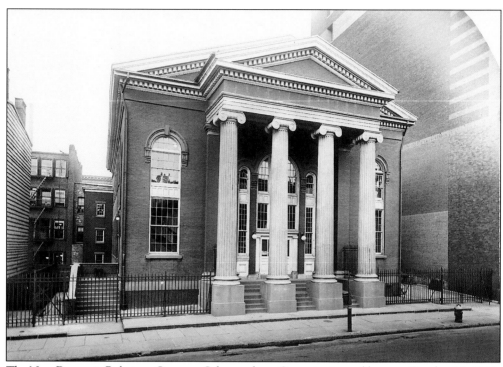

The New Domestic Relations Court on Schermerhorn Street is pictured here on October 10, 1921.

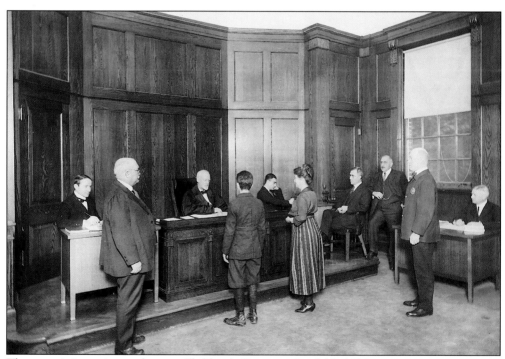

The court is in session at the new Children's Court on April 17, 1922.

The American Theater, located at 779-787 Bedford Avenue between Flushing and Park Avenues in the Wallabout section, collapsed between 4 and 5 p.m. on November 29, 1921.

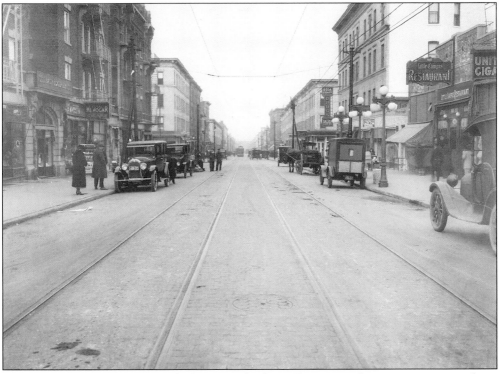

Pictured is Franklin Avenue looking north from Eastern Parkway as it appeared on November 28, 1923.

This September 27, 1922 photograph view is looking east from the north sidewalk at 685 Greene Avenue located between Throop and Sumner Avenues.

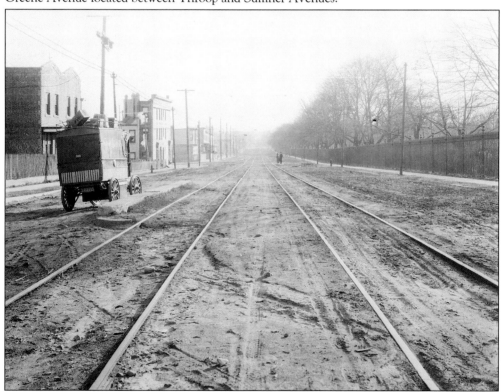

This December 20, 1924 photographic view is looking south on Gravesend (McDonald) Avenue from Seeley Street. Greenwood Cemetery is located to the right. Gravesend Avenue was opened to the north in 1838 and widened in 1875.

This October 12, 1921 photograph view looks on the east side of Lafayette Avenue from Rockwell Place to Ashland Place. The Brooklyn Academy of Music is located to the right.

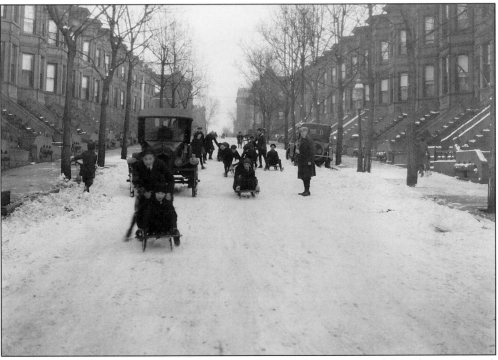

Children are seen playing on 50th Street near 4th Avenue after a snow fall in the Sunset Park section of Brooklyn on February 19, 1924.

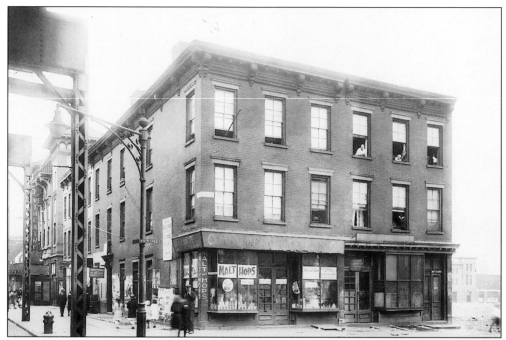

This is the corner of 5th Avenue and 3rd Street in Park Slope as it appeared on May 21, 1922. It was at this site that the historic Cortelyou House, "Old Stone House," stood. On August 27, 1776, over 250 out of 400 Maryland soldiers under the command of Lord Stirling were killed in combat with British troops under Lord Cornwallis.

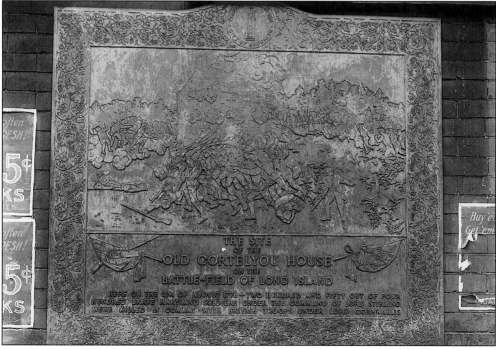

The Battle of Long Island memorial tablet stood on the side of the building on 5th Avenue and 3rd Street.

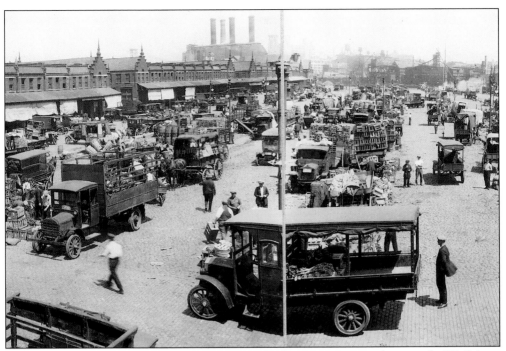

This view of Farmers Square looking north shows the farmers' wagons and carts at the Wallabout Market on July 18, 1924.

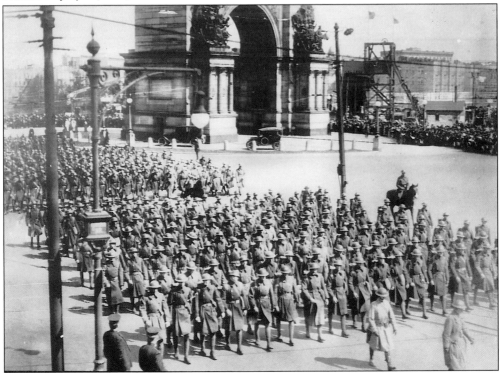

The return of the 27th Division at the Brooklyn parade passes the Soldiers and Sailors Arch at the entrance to Prospect Park on March 24, 1919.

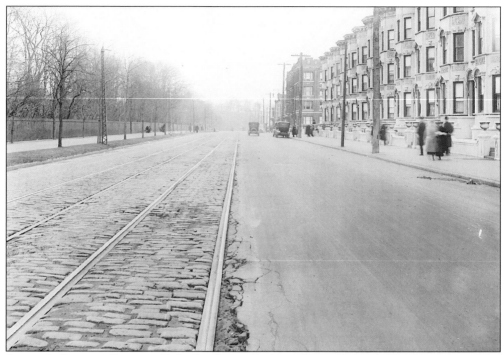

Pictured above is Prospect Park Southwest looking from 9th to 10th Avenues in this March 12, 1922 image.

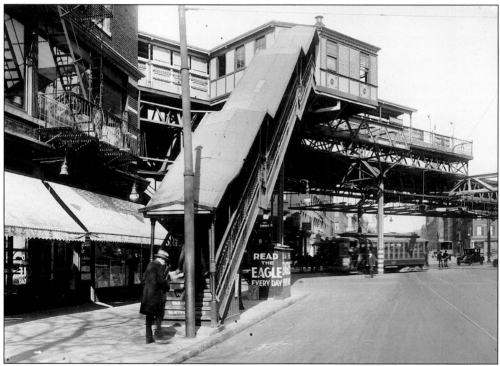

Looking east on Lafayette Avenue shows stairs removed to the sidewalk at Fulton Street in this April 27, 1923 image.

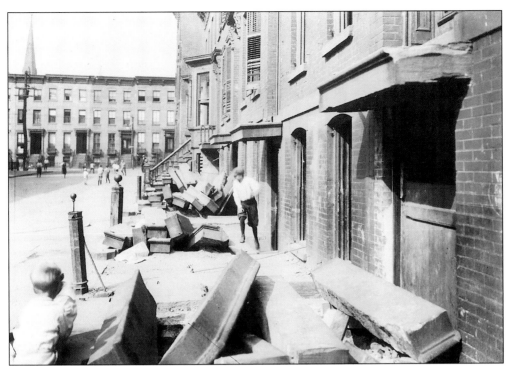

This image shows numbers 11 through 5 Manhasset Place on August 24, 1923. Manhasset Place no longer exists. Plans to construct the Gowanus Expressway called for its condemnation. The bell tower of St. Stephen on the corner of Summit and Hicks Streets can be seen in the background.

This is a viewpoint looking south at the junction of Flatbush Avenue and Eastern Parkway. Grand Army Plaza Branch of the Brooklyn Public Library now stands on this site. The old reservoir with its tower can be seen in the background of this July 14, 1921 photograph.

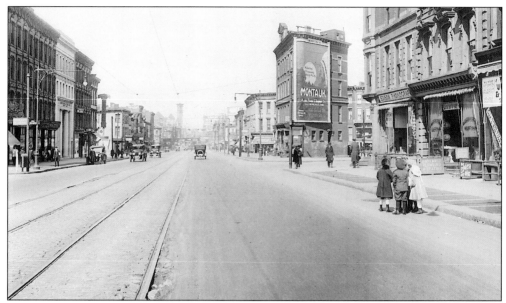

This is Flatbush Avenue as it appeared from St. Marks Avenue to Bergen Street on March 12, 1922.

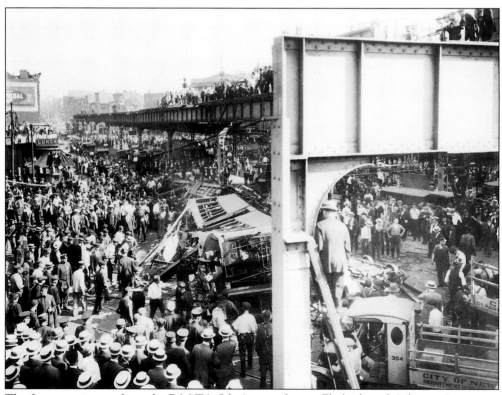

The famous train wreck on the B.M.T.'s 5th Avenue line at Flatbush and Atlantic Avenues is shown in this June 25, 1923 image.

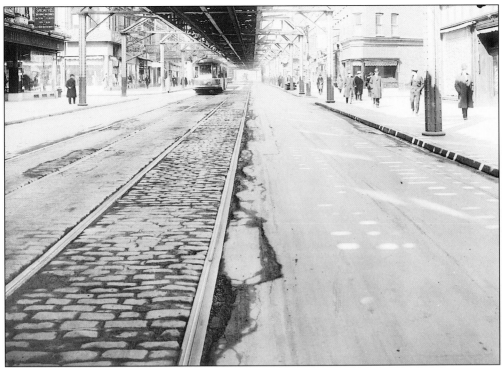

This is a March 12, 1922 image looking on Fulton Street from Bridge to Lawrence Streets.

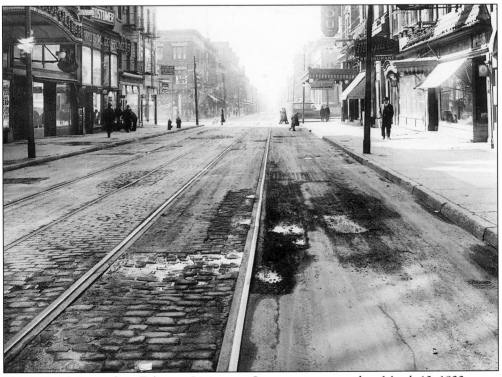

This is Smith Street from Fulton to Livingston Streets as it appeared on March 12, 1922.

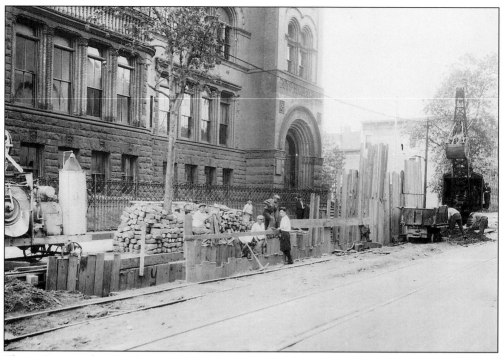

This is Boys High School located on Marcy Avenue between Putnam Avenue and Madison Street in the Bedford Stuyvesant section on August 28, 1924.

A terrific storm of wind and rain on June 26, 1923, tore off the roofs of the homes at numbers 601, 603, and 605 Putnam Avenue. This image was taken on June 28, 1923.

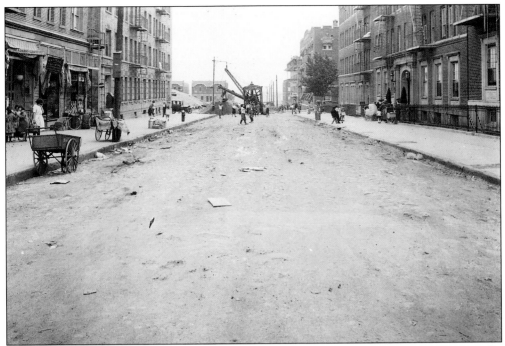

This is Schnectady Avenue as it appeared looking south from Union to President Streets in the Crown Heights section of Brooklyn on June 11, 1923.

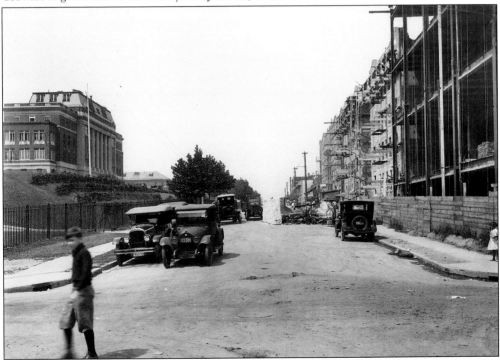

The photograph above shows Crown Street looking west from Troy Avenue in Crown Heights. This area was once known as Pig Town. Peck Memorial Hospital can be seen to the left in this August 16, 1923 image.

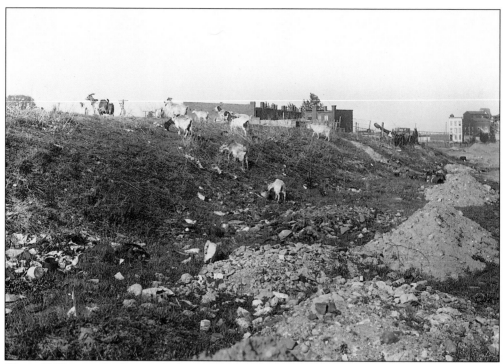

"Goat Hill" is in the heart of what was once known as Pig Town, in Crown Heights. This photograph was taken on May 21, 1922.

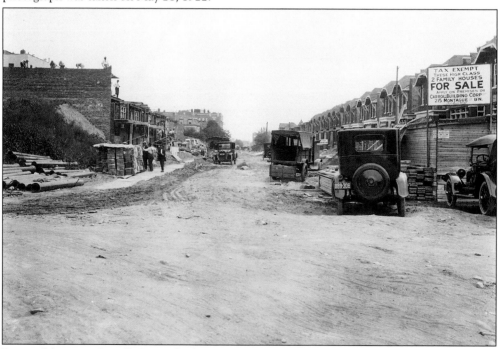

Pictured here is Carroll Street looking east from Schnectady Avenue in Crown Heights in this August 16, 1923 image. Notice the sign declaring Tax Exemption for the new two-family houses.

Two

BUSHWICK

Borough President Riegelmann lays the cornerstone of the Williamsburg Bath at Bedford and Metropolitan Avenues on March 9, 1922.

Pictured here is the new Metropolitan Avenue Bath, also known as the Williamsburg Bath, on the corner of Metropolitan and Bedford Avenues on May 24, 1923.

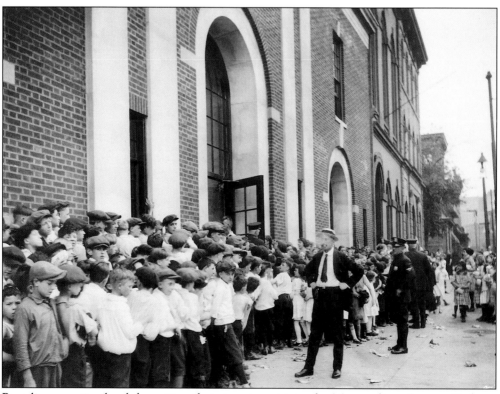

Boys lineup patiently while waiting their turn to get into the Metropolitan Avenue Bath on June 6, 1923.

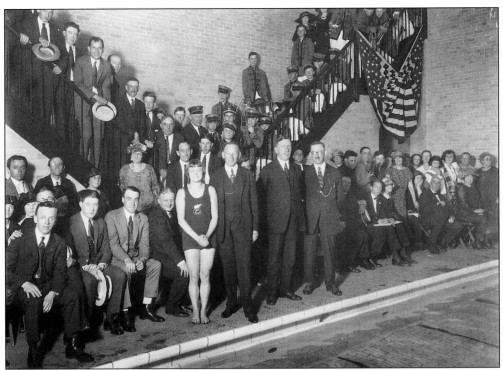

Aileen Riggin, an amateur champion diver of the world, stands with Borough President Riegelmann at the opening ceremonies of the Metropolitan Bath on June 4, 1923.

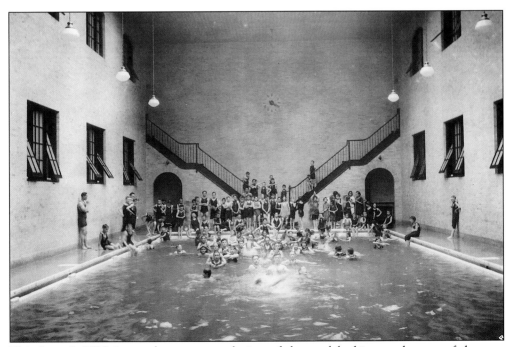

This June 6, 1923 image shows a general view of the pool looking to the rear of the new Metropolitan Avenue Bath.

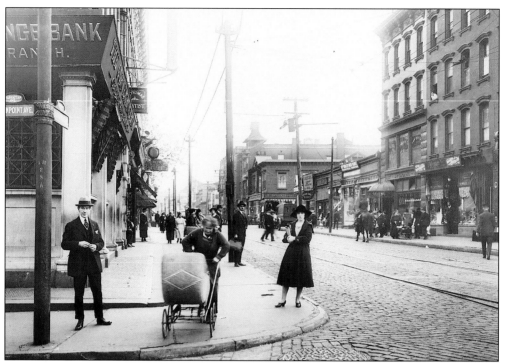

This is a view of the east side of Manhattan Avenue looking south from Greenpoint Avenue. Greenpoint was known as "The Garden Spot of the World." This image was taken on October 10, 1921.

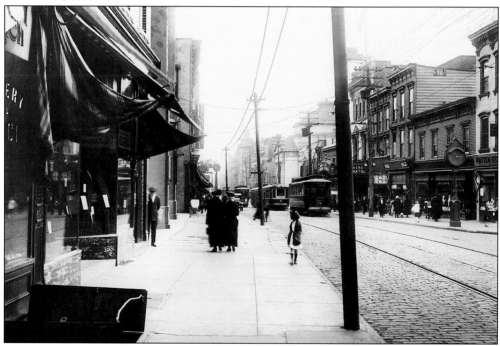

This is a view of the east side of Manhattan Avenue looking south from Noble Street in Greenpoint on October 10, 1923.

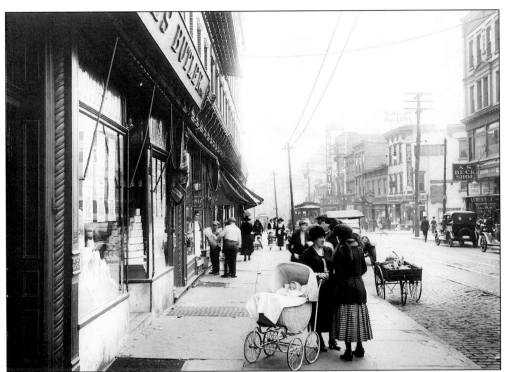

This view is of the east side of Manhattan Avenue looking south between Milton and Noble Streets in Greenpoint on October 10, 1923.

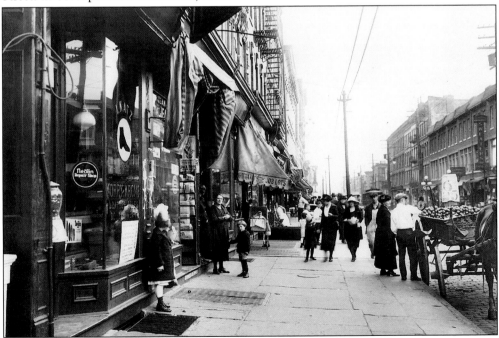

The vegetable man sells six pounds of potatoes for 25¢ on the east side of Manhattan Avenue looking south between Norman and Meserole Avenues. This image was taken on October 10, 1923.

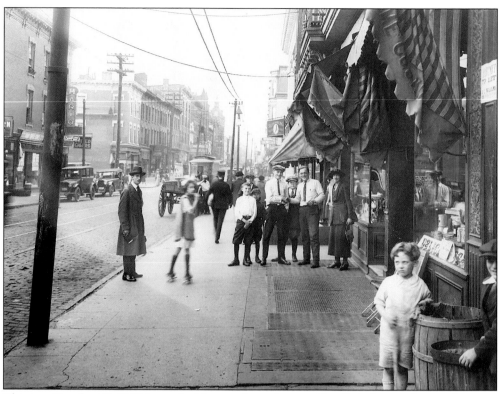

This is an October 10, 1921 image looking north on the east side of Manhattan Avenue between Norman and Nassau Avenues.

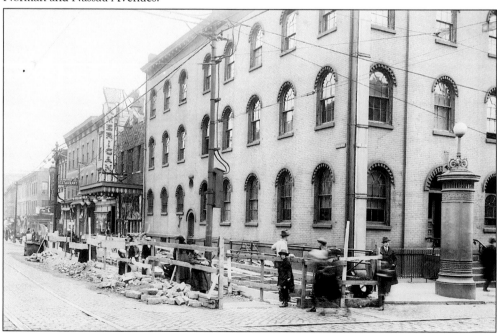

This is a March 29, 1922 image looking north on the east side of Manhattan Avenue from Greenpoint Avenue to Kent Street.

This is an October 25, 1921 image looking at the corner of Calyer Street and Manhattan Avenue where the Greenpoint Savings Bank is located. Saint Anthony's Church can be seen to the right.

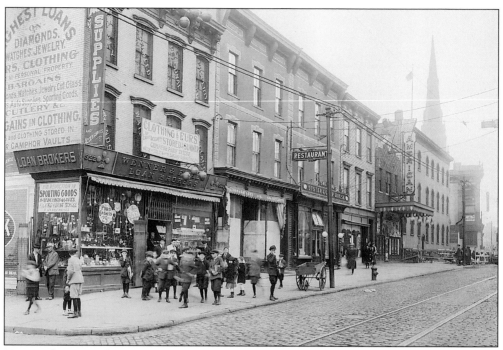

Here is the east side of Manhattan Avenue looking south from Kent Street to Greenpoint Avenue in this March 29, 1922 image.

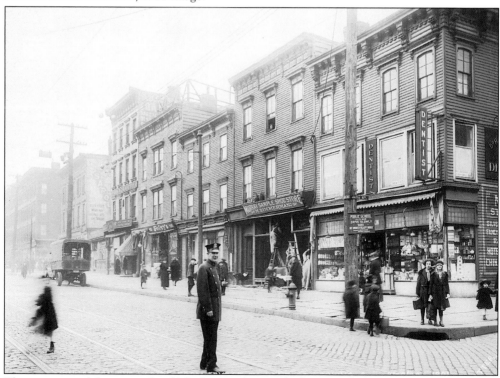

This is a view of the west side of Manhattan Avenue looking south from Java to Kent Streets. This image was taken on March 29, 1922.

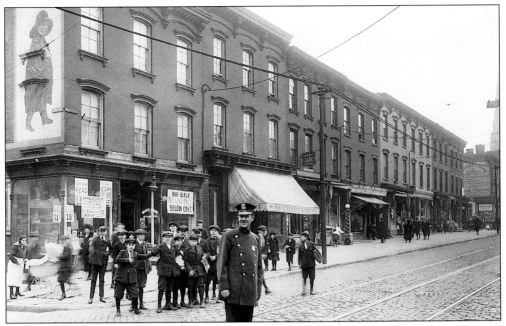

This view is of the east side of Manhattan Avenue looking south from Java to Kent Streets. The police officer watches as students carrying books cross the avenue on their way to school on March 29, 1922.

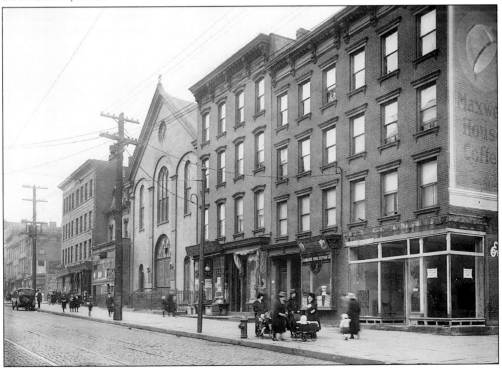

A Jewish synagogue stands in the middle of the block on the west side of Manhattan Avenue looking south from India to Java Streets. Notice the ad for Maxwell House Coffee on the side of the building to the right in this March 29, 1922 image.

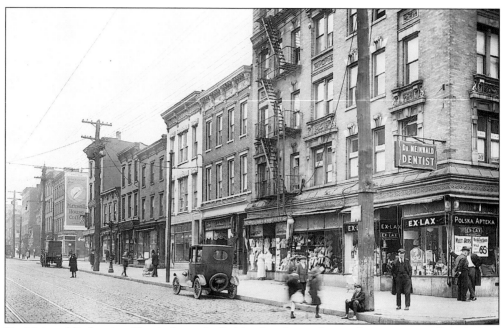

Dr. Meinwald's dentist office is above the Polska Apteka on the southwest corner of Manhattan Avenue and Huron Street. This image was taken on March 29, 1922.

This is the southeast corner of Manhattan Avenue and Greene Street as it appeared on March 29, 1922.

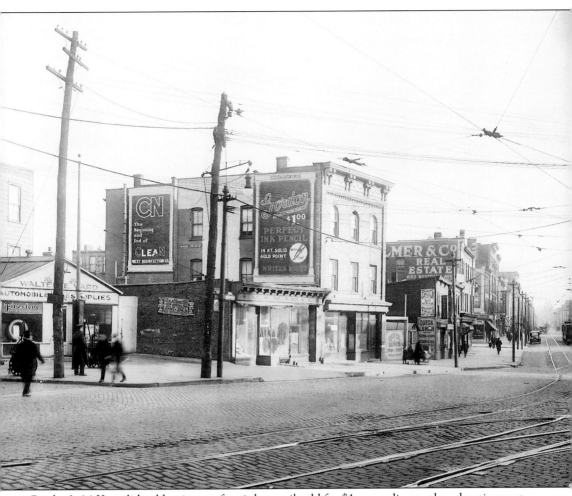

Gordon's 14 Kt. solid gold point, perfect ink pencil sold for $1, according to the advertisement on the building located on the southeast side of Manhattan Avenue, looking from Ash Street to Box Street in the northern section of Greenpoint near Newtown Creek on April 2, 1922.

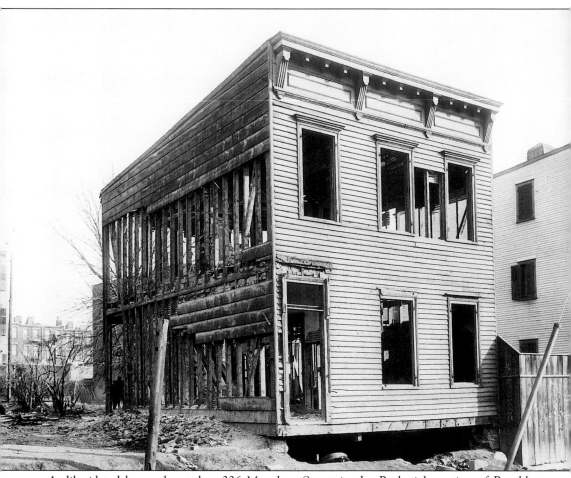

A dilapidated home, located at 326 Menahan Street in the Bushwick section of Brooklyn between Wyckoff and Nicholas Avenues near the county line of Queens, stands abandoned on March 28, 1923.

Three

FLATBUSH

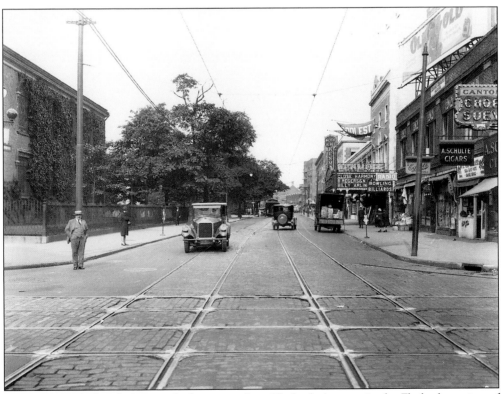

This view is of Church Avenue looking west from Flatbush Avenue in the Flatbush section of Brooklyn on June 6, 1929.

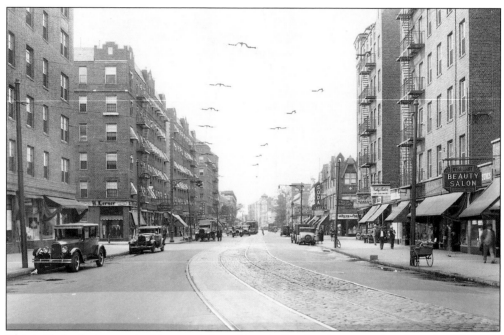

This is Flatbush Avenue looking south from Lincoln Road as it appeared on June 6, 1929.

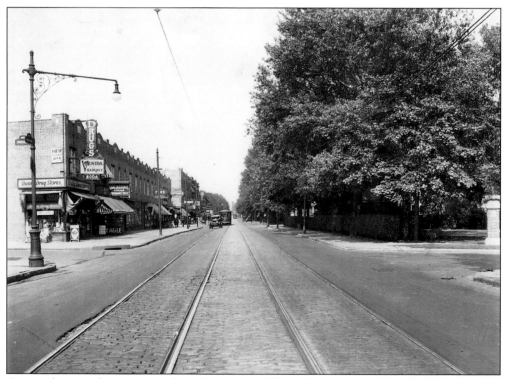

A typical corner drugstore stands at the corner of Church Avenue and Stratford Road in this June 6, 1929 image.

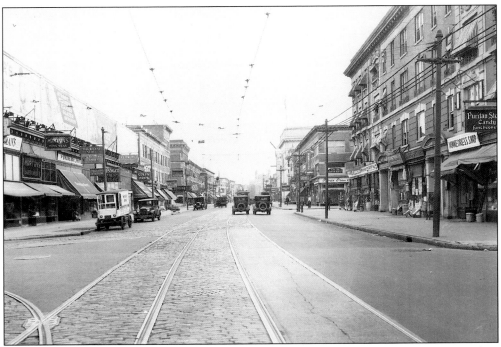

This is a view of Flatbush Avenue looking north from Cortelyou Road. This image was taken on June 6, 1929.

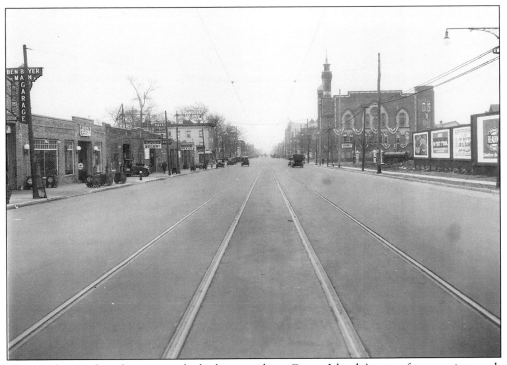

This newly paved roadway is seen by looking south on Coney Island Avenue from a point north of Avenue I. A Jewish temple stands proudly to the right of this March 4, 1929, photograph.

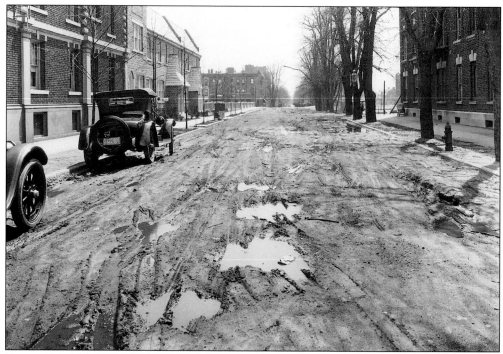

Here is East 18th Street looking south from Caton Avenue in this April 19, 1924 image.

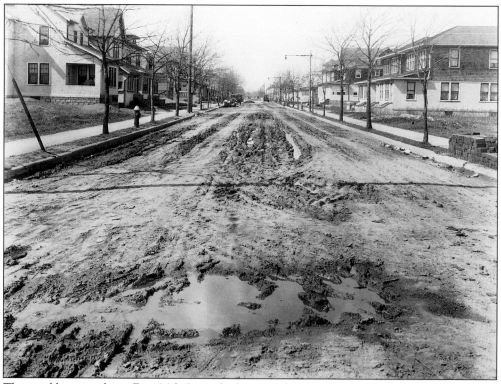

This muddy scene shows East 26th Street looking north from Avenue K. on April 23, 1924.

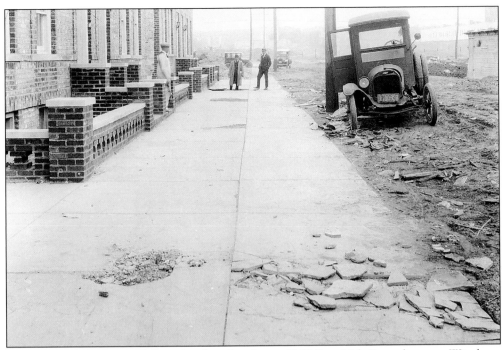

An old Chevrolet automobile is abandoned in front of 118 East 95th Street between Winthrop Street and Rutland Road. This image was taken on May 20, 1924.

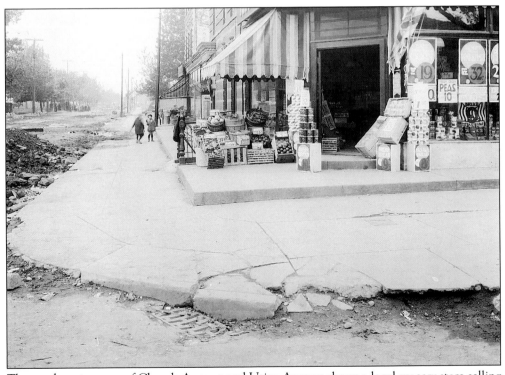

The northwest corner of Church Avenue and Utica Avenue shows a local grocery store selling fruits and vegetables in this May 20, 1924 image.

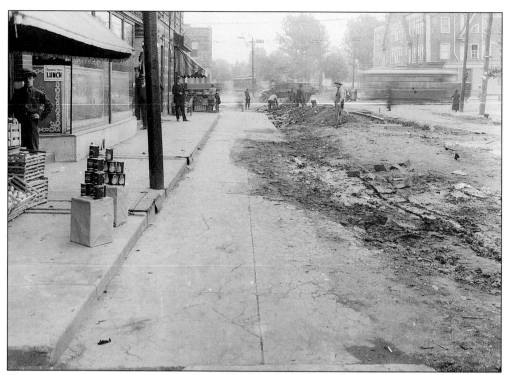

The sign in the restaurant window on Church Avenue between East 49th Street and Utica Avenue advertises a "Business Men's Lunch" on May 20, 1924.

Trolley #3166 stops and the conductor looks it over on the southeast side of Church Avenue looking from East 49th Street on November 11, 1923.

The Church Avenue sewer was being installed as we look west from East 51st Street on January 29, 1924.

This November 21, 1923 scene shows the trolley tracks looking east on Church Avenue from East 57th Street in East Flatbush.

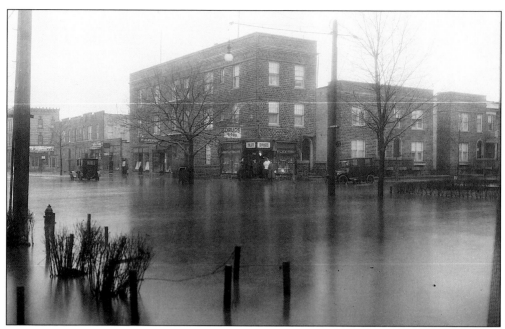

The intersection of Clarendon Road and East 26th Street shows the southeast corner flooded after a violent rain storm flooded the entire area. This image was taken on March 1, 1925.

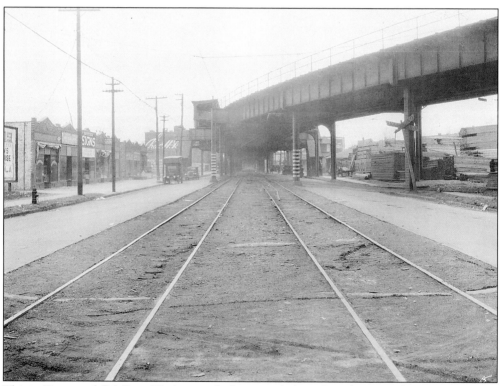

This is Gravesend (McDonald) Avenue looking south from Cortelyou Road as it appeared on December 16, 1924. The old Culver Line can be seen to the right.

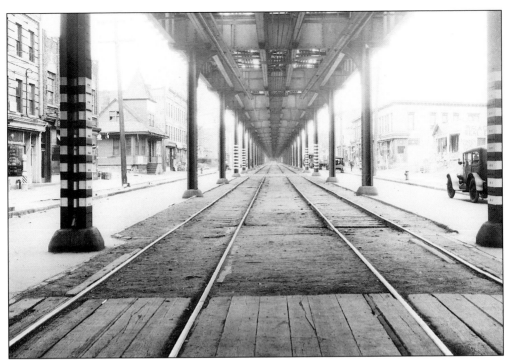

This is Gravesend Avenue as it appeared looking south from Ditmas Avenue on December 16, 1924.

A woman waits on the northeast corner of Kings Highway and Church Avenue for a trolley on October 4, 1923.

This is Kings Highway as it appeared looking north from Beverly Road on October 11, 1921.

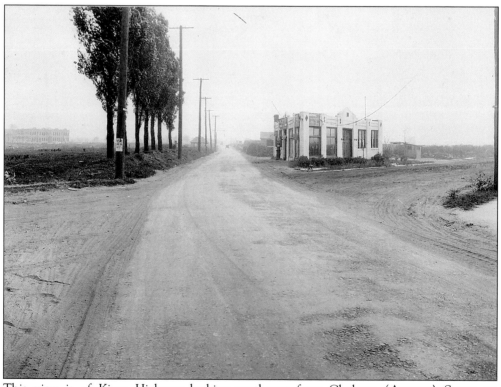

This view is of Kings Highway looking southwest from Clarkson (Avenue) Street on October 4, 1923.

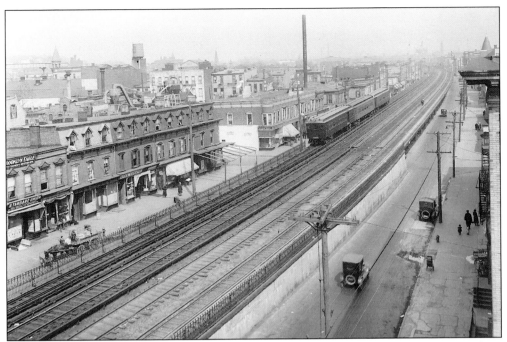

Here is a bird's-eye view of the Long Island Railroad on Atlantic Avenue looking east from Snediker Avenue in East New York on April 20, 1923.

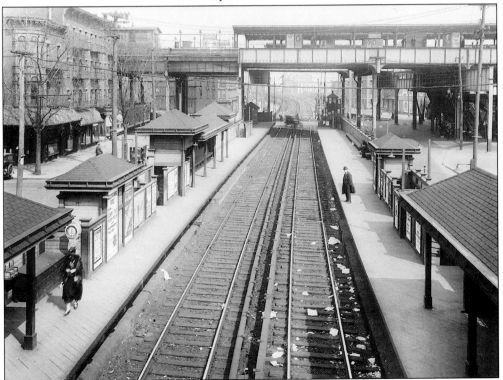

Pictured is the East New York station, of the Long Island Railroad with the Canarsie Elevated Subway Line crossing over on Van Sinderen Avenue, looking east on April 20, 1923.

Pictured is the Long Island Railroad crossing looking south on Euclid Avenue on Atlantic Avenue in East New York. This image was taken on April 20, 1923.

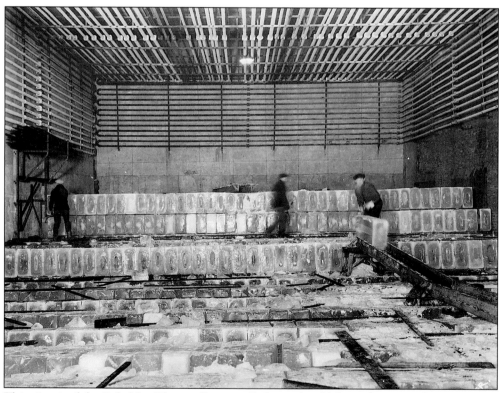

This view is of the Rubel Ice Plant in Brownsville located at Blake and Van Sinderen Avenues looking east. Pictured is the ice stored in the northeast wing of the building on March 15, 1924.

The Municipal Bath in Brownsville stands in the middle of the block on Pitkin Avenue near Watkins Street in this April 13, 1922 image.

The P. Sabbarese Italian & American Grocery Store stood on the southwest corner of Lefferts and New York Avenues in the north part of Flatbush near Crown Heights. This photograph was taken on April 11, 1923.

This is a general view looking south on New York Avenue at Lefferts Avenue. Sewers were being installed on New York and Lefferts Avenues when this photograph was taken on April 11, 1923.

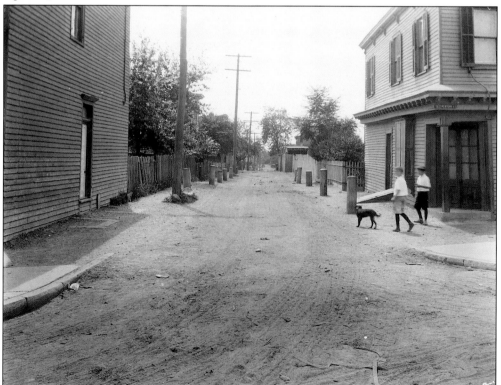

Here is Rochester Avenue looking south from East New York Avenue on August 17, 1923. This area was once known as Pig Town. Today it is near Lincoln Terrace Park.

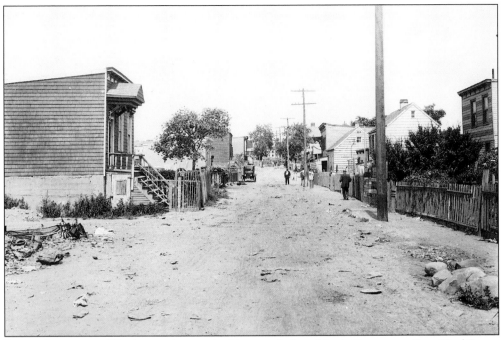

Pictured is a view of Rochester Avenue looking north from Maple Street near East 52nd Street on August 17, 1923.

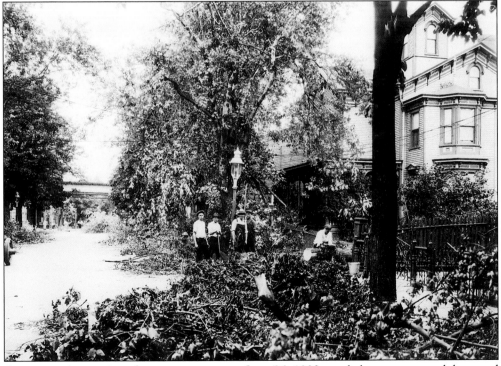

A massive cleanup is underway as a storm on June 26, 1923 toppled many trees and destroyed property on Barbey Street between Atlantic Avenue (in the background) and Fulton Street near Highland Park. This photograph was taken three days later on June 29, 1923.

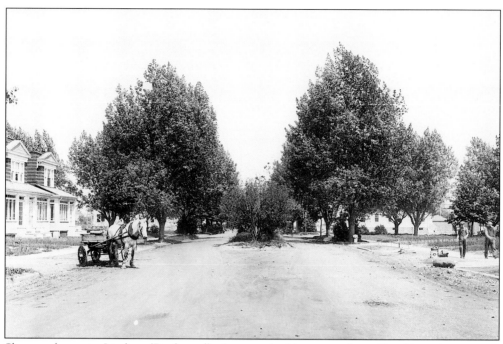

Shown above is Linden (Boulevard) Avenue looking east from Brooklyn Avenue on May 21, 1922.

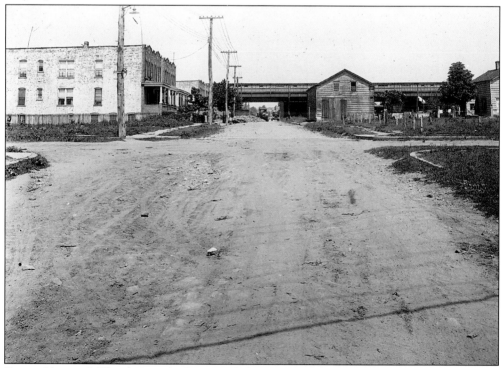

Pictured here is Miller Avenue looking north from New Lots (Avenue) Road across Riverdale Avenue. The Van Sicklen Avenue station on today's number "3" train is in the background of this August 9, 1923 image.

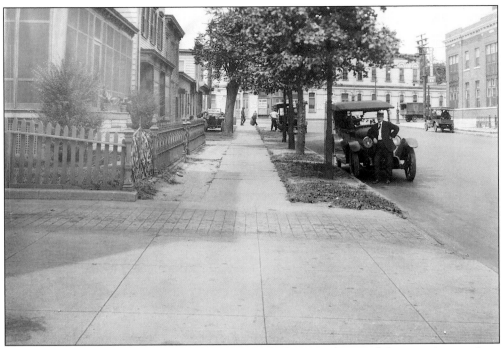

Here is the west sidewalk of Pennsylvania Avenue looking north towards Jamaica Avenue from #14 on August 17, 1923.

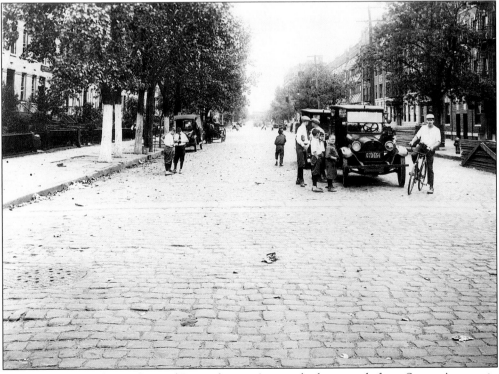

Pictured above is the roadway of Pennsylvania Avenue looking south from Sutter Avenue in East New York on August 17, 1923.

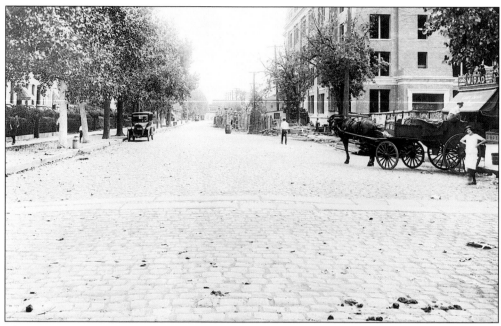

The scene above is Pennsylvania Avenue looking south from Blake Avenue in East New York. Thomas Jefferson High School was still under construction when this photograph was taken on August 17, 1923.

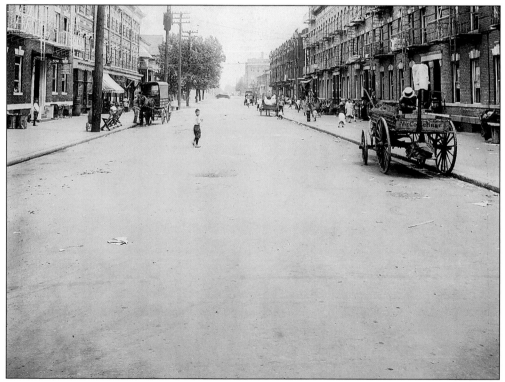

Pictured above is Dumont Street looking east from Alabama Avenue in East New York on July 2, 1923.

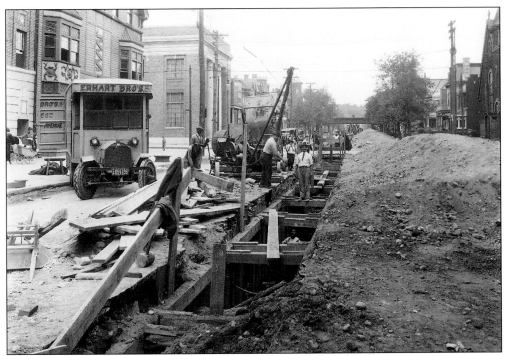

Sewers are being installed on Pennsylvania Avenue looking north between Glenmore and Liberty Avenues near Broadway Junction on September 27, 1923.

Pictured here is the south sidewalk of Jamaica Avenue near Vermont Avenue looking west from #112 near Broadway Junction. Fulton Street is in the background of this September 11, 1923 image.

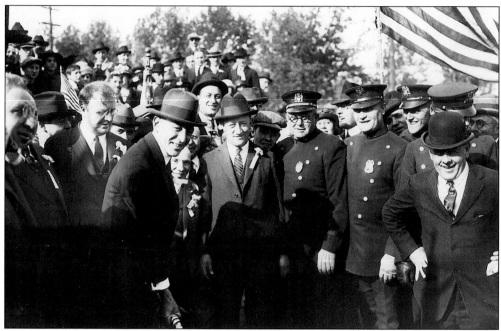

Borough President Riegelmann breaks ground on May 11, 1922 for the new high school, as Mayor Hylan (to Riegelmann's rear) as well as other politicians look on. Thomas Jefferson High School is located at Pennsylvania and Dumont Avenues in East New York.

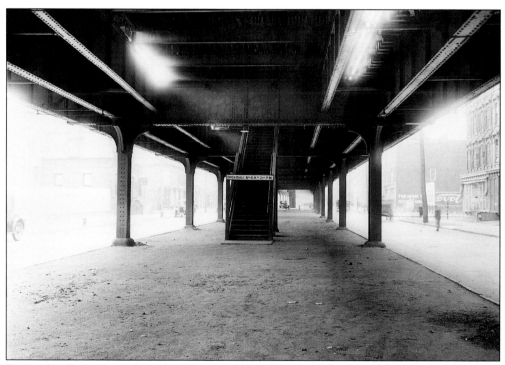

Pictured is the staircase from the Warwick Street Station of the Long Island Railroad looking west on Atlantic Avenue near Highland Park in this April 20, 1923 image.

Four

FLATLANDS

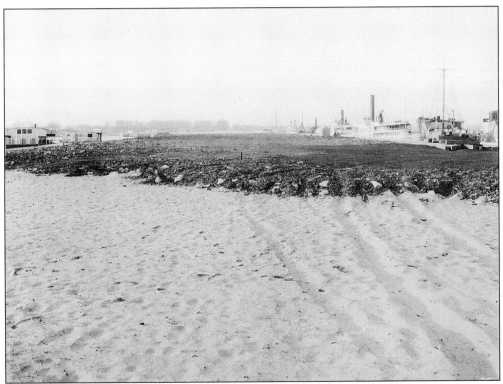

Flatbush Avenue Extension, looking north towards Avenue V, shows the cinder surface. The ferries to the right would take you to the Rockaways prior to the construction of the Marine Parkway Bridge in 1937. Kings Plaza would later be built in the top right section of this photograph.

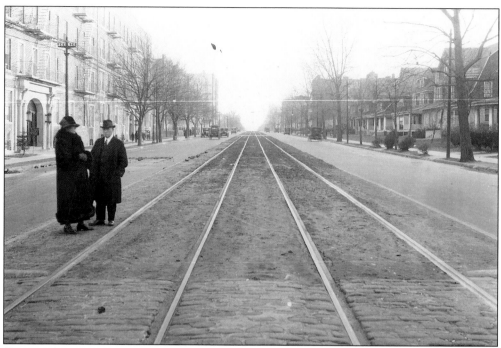

Shown above is Ocean Avenue looking south from Avenue G (Glenwood Road) on December 4, 1924.

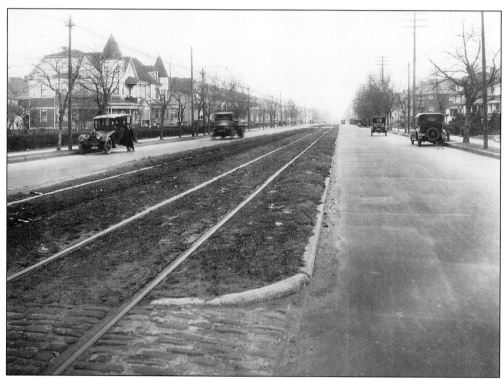

Here is Ocean Avenue looking south on the west side from Avenue L on December 4, 1924.

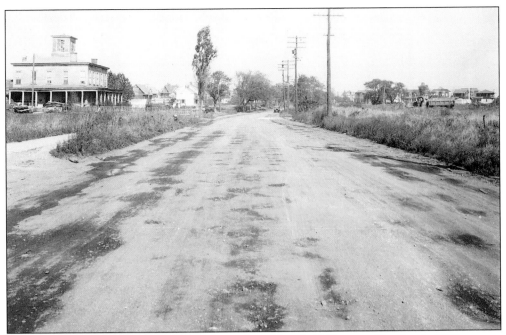

Pictured is Kings Highway looking northeast from Mansfield Place on October 2, 1923.

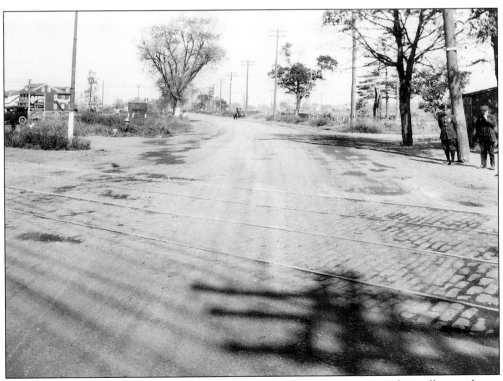

Here is Kings Highway looking northeast from Nostrand Avenue across the trolley tracks on October 2, 1923.

This view is of Kings Highway looking west from Flatbush Avenue on October 2, 1923.

Shown above is Kings Highway looking east from Flatbush Avenue on October 2, 1923.

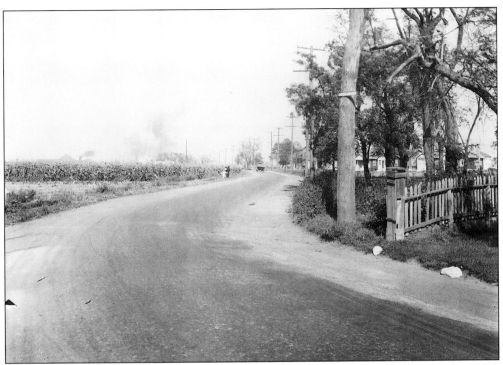

Cornfields can be seen in this photograph looking northeast on Kings Highway from Avenue I. on October 2, 1923.

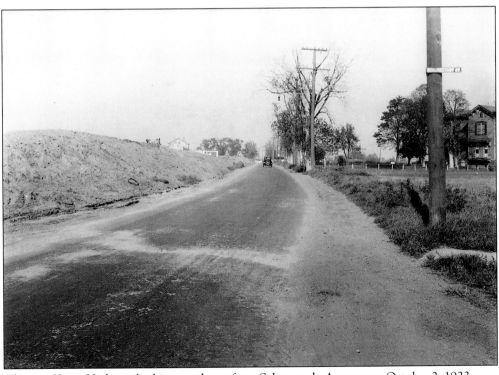

Above is Kings Highway looking northeast from Schnectady Avenue on October 2, 1923.

Kings Highway and East 40th Street show the curve in the roadway in this October 11, 1921 photograph.

This is an October 11, 1921 image of Kings Highway and Mill Lane near East 40th Street.

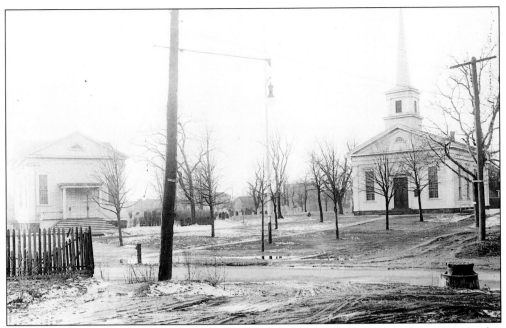

Kings Highway and Alton Place show the Flatlands Reformed Church and cemetery in this February 9, 1922 image.

Pictured above is Kings Highway looking northeast from East 51st Street on October 2, 1923.

Above is Kings Highway looking north from Clarendon Road on October 2, 1923.

Public School 121 proudly flies the United States flag above its one-room schoolhouse located on Kings Highway north of East 55th Street near Clarendon Road on October 2, 1923.

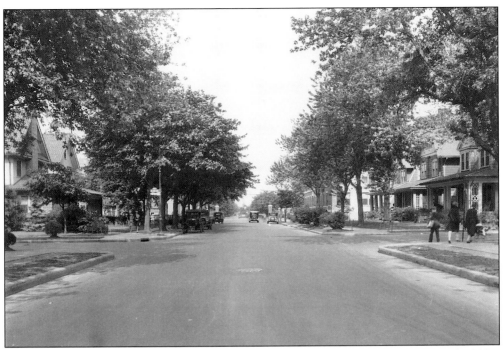

Here is Avenue J. looking east across East 19th Street. This image was taken on June 6, 1929.

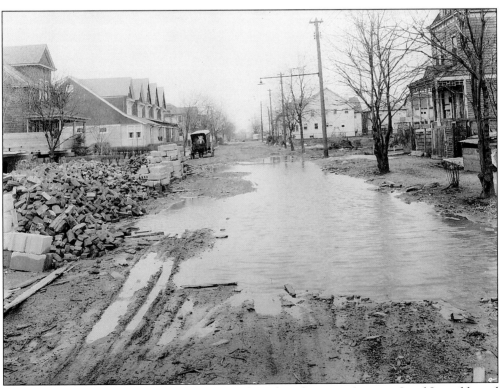

Heavy rains left East 27th Street, looking north midway between Avenues I and J, muddy and flooded on April 19, 1924.

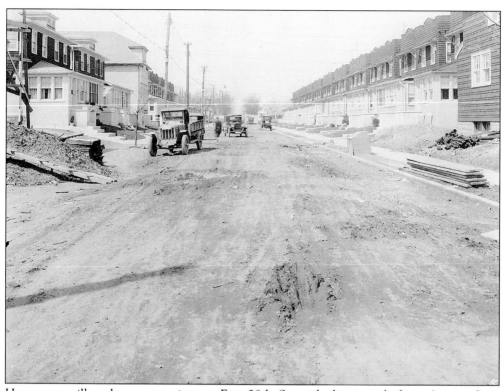

Homes are still under construction on East 28th Street looking north from Avenue J. in Midwood on April 19, 1924.

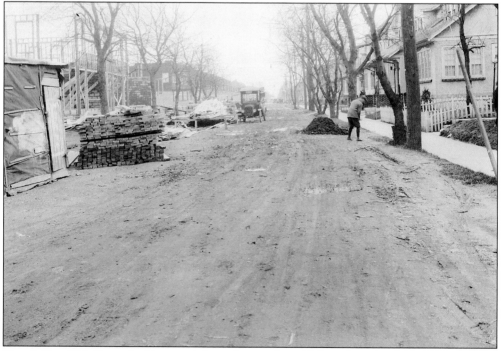

Here is East 28th Street looking south from Avenue I. in Midwood on April 19, 1924.

Above is East 29th Street looking south from Avenue J. on April 19, 1924.

This view is of East 29th Street looking north from Avenue K. on April 19, 1924.

This scene is of East 29th Street looking north from #1060 located between Avenues J and K on April 19, 1924.

Above is Delemere Place looking south from Avenue K. on April 23, 1924.

Pictured here is Mansfield Place looking south from Avenue K. on April 23, 1924.

Pictured above is a view of Mansfield Place looking north from Avenue J. on April 23, 1924.

Here is Mansfield Place looking south from #840 on April 23, 1924.

Above is Bedford Avenue looking south on the east roadway from #3077 on April 23, 1924.

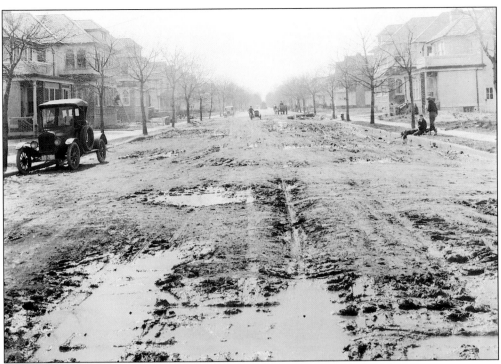

Pictured is Avenue K. looking west from East 26th Street on April 23, 1924.

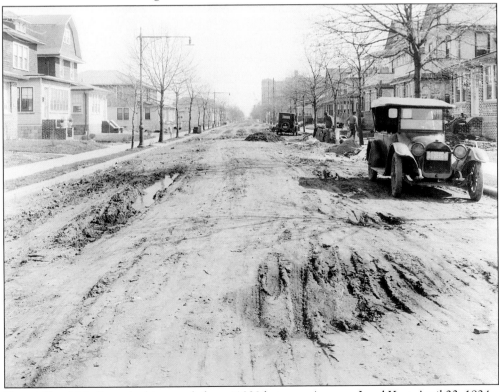

Here is East 26th Street looking south from #1039 between Avenues J and K on April 23, 1924.

This view is of Avenue L. looking east from Bedford Avenue. Public school 193 is to the left in this April 23, 1924 photograph.

Pictured above is East 34th Street looking south toward Kings Highway from #1406 on February 4, 1924.

78

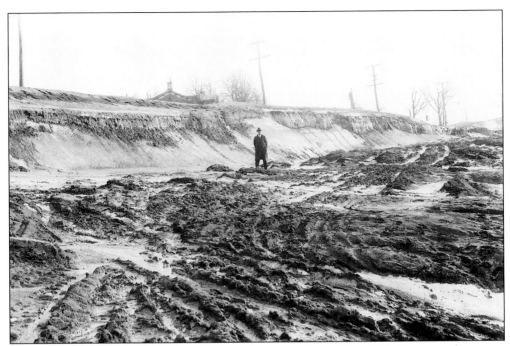

The area looking south on Avenue H. from the center line of East 48th Street was known as "the Sand Pit." This photograph was taken on February 28, 1924.

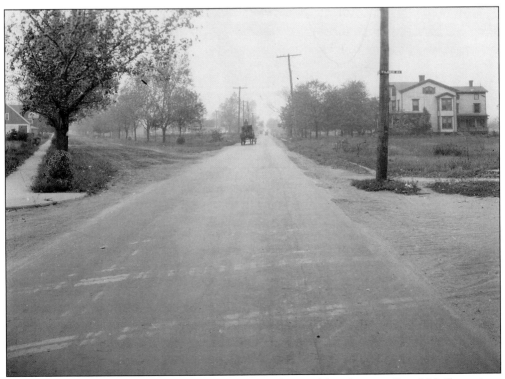

Pictured above is Kings Highway looking northeast from Tilden Avenue. East 56th Street is to the left in the photograph taken on October 4, 1923.

This is Island Avenue (Veterans Avenue) looking east across Avenue U. near East 72nd Street in Bergen Beach on July 18, 1929.

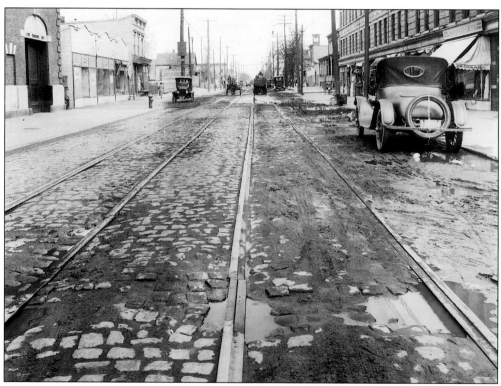

Above is Rockaway Parkway looking south from Farragut Road in Canarsie on May 13, 1924.

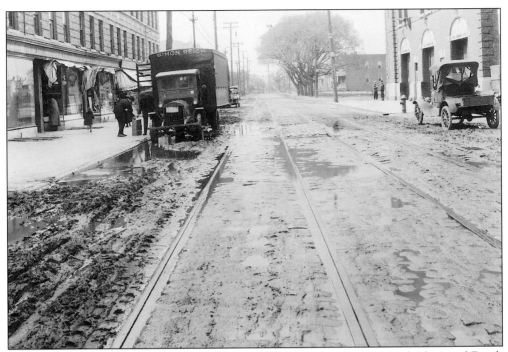

Here is Rockaway Parkway looking north from #1376 between Farragut and Glenwood Roads on May 13, 1924.

Sewer pipes are laid out, May 26, 1924, along East 93rd Street looking south from Flatlands Avenue in Canarsie.

Above is Farragut Road looking east from the north roadway 50 feet east of New York Avenue in the Midwood section on May 26, 1924.

This view is of Linden Boulevard looking east from Remsen Avenue on May 21, 1922.

Five

NEW UTRECHT

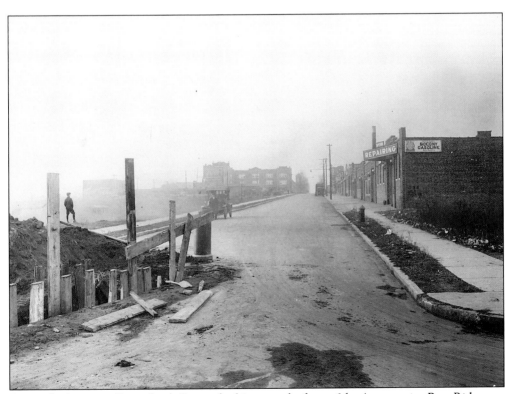

Pictured above is Sixty-third Street looking north from 6th Avenue in Bay Ridge on December 1, 1921.

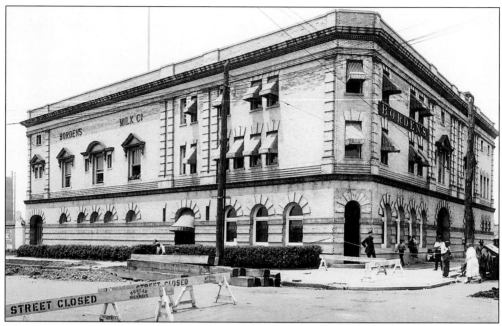

The Borden Milk Company was located on the southwest corner of Ft. Hamilton Parkway and 60th Street in Borough Park. This image was taken on June 10, 1922.

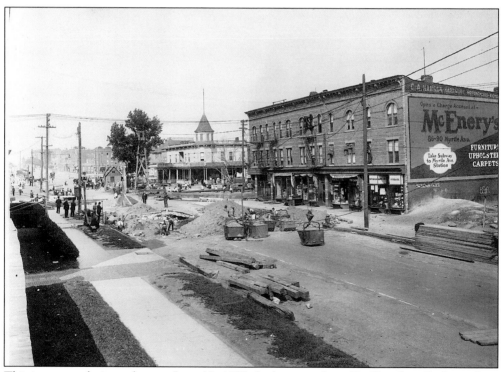

This is a general view taken on June 13, 1922, looking north on Ft. Hamilton Parkway from 61st Street. Part of the street had collapsed.

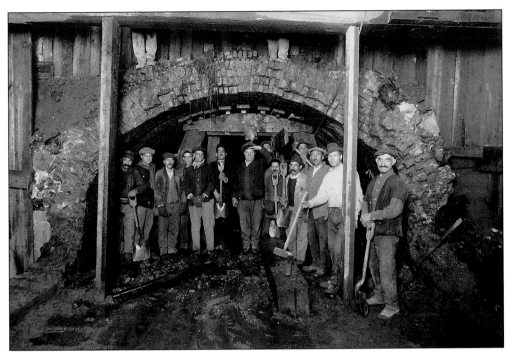

Men worked in the sewer at the end of the arch located at 10th Avenue and 60th Street looking west on November 6, 1922.

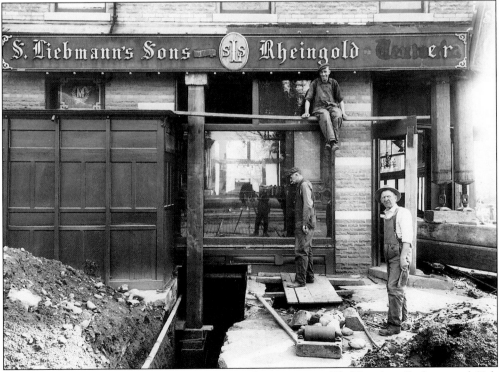

Men worked to support the building on the southeast corner of Ft. Hamilton Parkway and 60th Street on June 26, 1922.

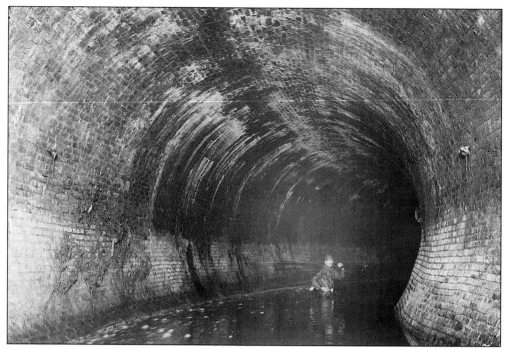

Pictured above is a sewer on 6th Avenue looking north at a curve at 6th Avenue and 62nd Street. This image was taken on March 27, 1923.

Here is the junction of 60th Street and Ft. Hamilton Parkway looking southeast at its present condition on May 4, 1923.

Pictured above is Ft. Hamilton Parkway looking south from 60th Street. The Sea Beach Train Station can be seen to the left in this May 4, 1923 image.

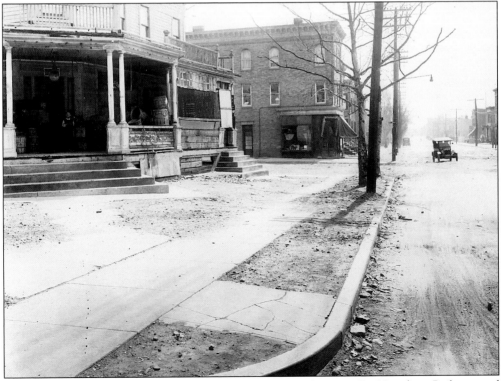

Above is the north sidewalk of 60th Street looking east between Ft. Hamilton Parkway and 10th Avenue on May 4, 1923.

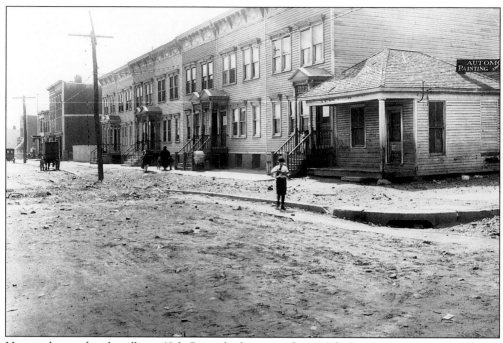

Here is the south sidewalk on 60th Street looking east from 10th Avenue on May 4, 1923.

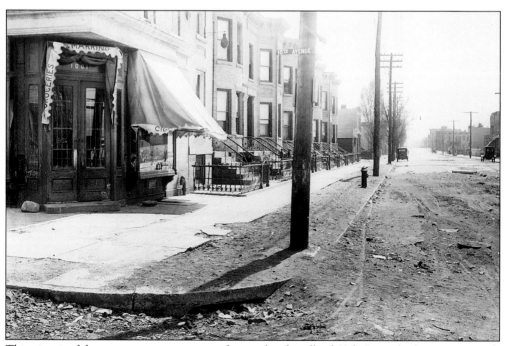

This view is of the corner grocery store on the north sidewalk of 60th Street looking east at 10th Avenue on May 4, 1923.

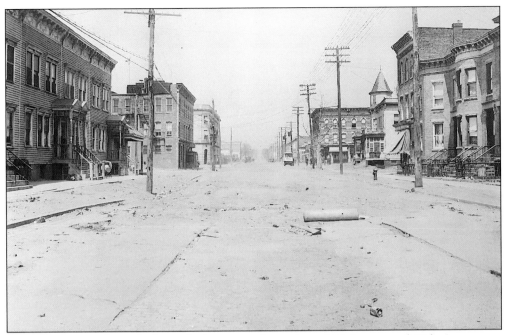

Pictured above is Sixtieth Street looking west from about 150 feet east of 10th Avenue on May 4, 1923.

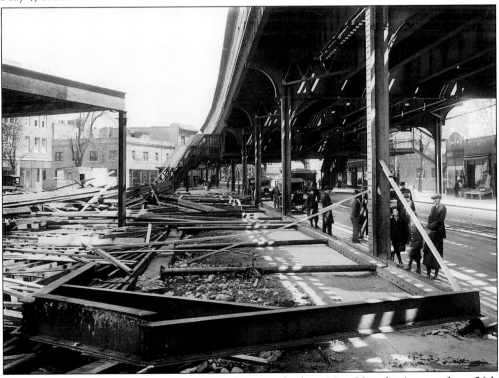

The scene above is of the west sidewalk looking north along New Utrecht Avenue from 56th Street where a building collapsed at 55th Street near 13th Avenue in Borough Park. This image was taken on May 10, 1923.

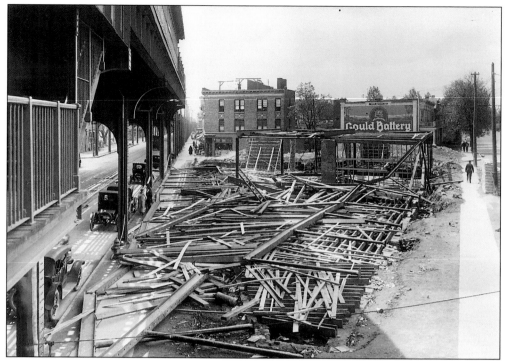

This is a general view of the collapsed building. The image was taken looking south from 55th Street to 56th Street along New Utrecht Avenue. Thirteenth Avenue is to the right of this May 10, 1923 photograph.

Above is Sixtieth Street looking north from 18th Avenue in New Utrecht on Halloween in 1923.

The Van Pelt Manor House stands along the east side of 18th Avenue between 81st Street and 82nd Street. This is a view looking north from 83rd Street showing the house as it appeared on March 10, 1924. The home was built c. 1670, and has been demolished. The house stood on the east side of the old village square of New Utrecht.

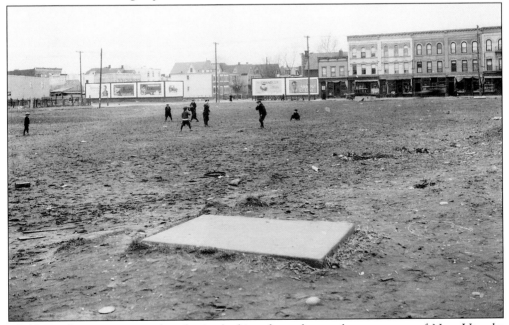

Children play at a proposed park site looking from the southwest corner of New Utrecht Avenue and 69th Street (Bay Ridge Avenue) toward 15th Avenue in Dyker Heights on March 10, 1924.

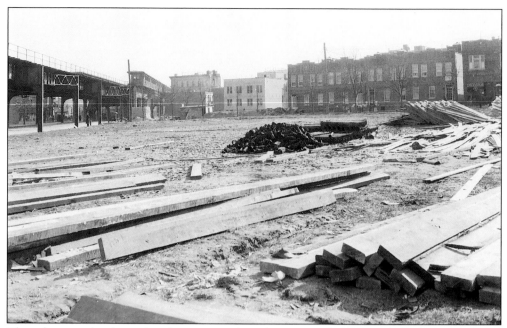

The photograph above is of a proposed park site in Sunset Park looking southeast from 10th Avenue and 42nd Street. New Utrecht Avenue is to the left in this March 14, 1924 photograph.

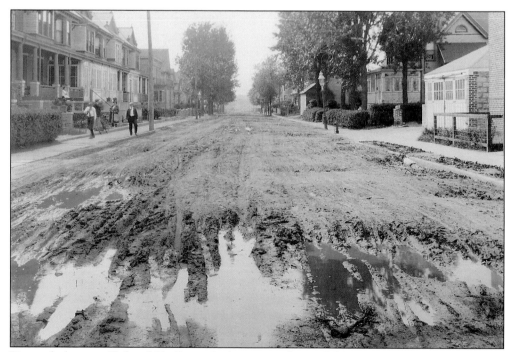

Pictured above is Eighty-fifth Street looking west from 17th Avenue in New Utrecht on May 23, 1924.

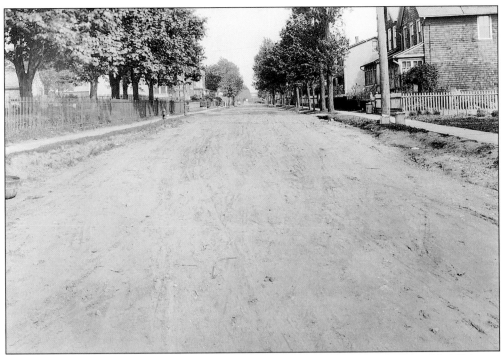

The scene above is of Eighty-fifth Street looking east from 16th Avenue on May 23, 1924.

Horse wagons are parked on 70th Street looking east from 10th Avenue in Dyker Heights on May 29, 1924.

Men level out 70th Street looking west from 11th Avenue in Dyker Heights on May 29, 1924.

This photograph was taken from #1926 67th Street, looking west between 19th and 20th Avenues in Bensonhurst, on August 29, 1924.

Pictured above is Eighty-seventh Street in Bay Ridge looking west from Narrows Avenue. You can see steamships in the background in Gravesend Bay. Leif Ericson Drive had not been constructed yet when this photograph was taken on August 28, 1924.

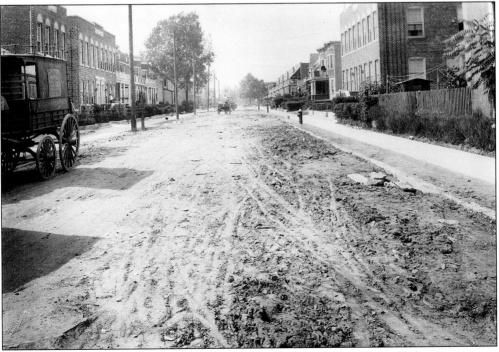

Here is Sixty-seventh Street in Bensonhurst looking west from 20th Avenue on August 29, 1924.

Public School 205 was still under construction when this photograph was taken. The image was taken looking south on 20th Avenue from 67th Street in Bensonhurst on August 29, 1924.

Pictured is Twentieth Avenue looking south from 68th Street on August 29, 1924.

This is a view of Twentieth Avenue looking north from 69th Street (Bay Ridge Avenue) on August 29, 1924.

Here is Twentieth Avenue looking south from 69th Street on August 29, 1924.

Above is Twentieth Avenue looking north from 70th Street on August 29, 1924.

Here is Seventy-fifth Street (Bay Ridge Parkway) looking west from New Utrecht Avenue in Dyker Heights on September 5, 1924.

Here is Seventy-fifth Street (Bay Ridge Parkway) looking east from 16th Avenue towards New Utrecht Avenue on September 5, 1924.

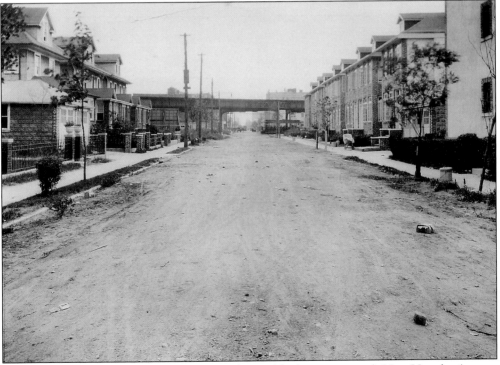

Above is Seventy-sixth Street looking east from 16th Avenue towards New Utrecht Avenue on September 5, 1924.

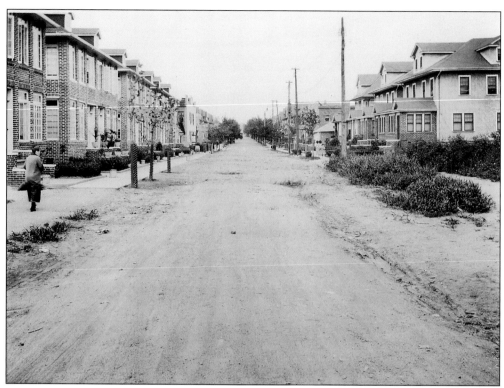

Here is Seventy-sixth Street looking west from New Utrecht Avenue on September 5, 1924.

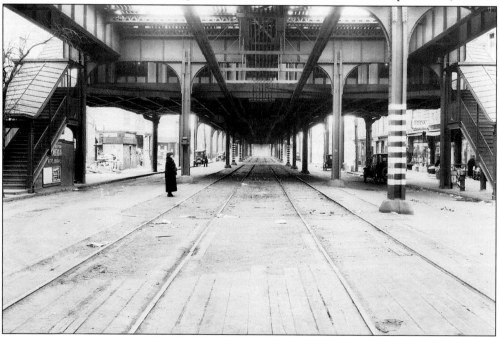

Here is a view of Gravesend (McDonald) Avenue looking south from 18th Avenue near the patent line between the former towns of Gravesend and New Utrecht. This image was taken on December 16, 1924.

Six

GRAVESEND

This is a view of Gerritsen's Park looking across Avenue U. showing the estate of the former secretary of the Navy, the Honorable William C. Whitney. In the distance can be seen the Gerritsen's Mill. The photograph was taken on November 18, 1920, from a spot in today's Marine Park near Burnett Street.

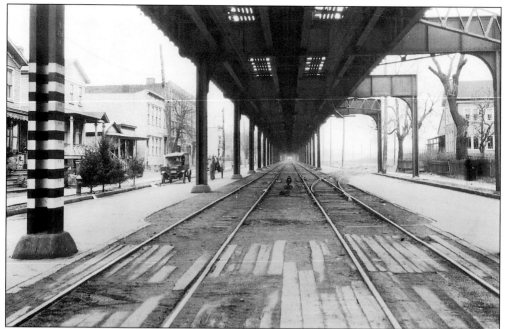

This is a view of Gravesend (McDonald) Avenue looking north from Avenue U. Please notice the tracks that diverted to the right. They once provided transportation to the Brooklyn Jockey Club (the Gravesend Racetrack) which closed in 1910. This photograph was taken on December 18, 1924.

Above is the east sidewalk of Gravesend (McDonald) Avenue looking north from Avenue T. The Brooklyn Jockey Club was once located to the right side of the photograph. The Samuel Hubbard Home can be seen to the left in this November 18, 1922 image.

This is 86th Street as it appeared on May 21, 1922, looking southeast to Avenue U. Today, Meucci Square is located to the left.

Above is the south sidewalk of Avenue T. looking east from West 5th Street. The old S.S. Simon and Jude Church can be seen in the distance to the left in this November 18, 1922 image.

Pictured above is West 5th Street looking south from Avenue S. in 1923. David A. Boody I.S. (Intermediate School) 228 For Magnet Studies would later be built to the left in 1930.

Above is the west side roadway of Ocean Parkway looking north from Avenue S. to Avenue R. on November 17, 1922. Ocean Parkway was completed in 1876.

This is the construction of the Avenue U. sewer looking southeast from West 5th Street. Public School 95, the Gravesend School, can be seen in the background as well as the Van Stryker Home on Van Sicklen Street in this December 3, 1921 image.

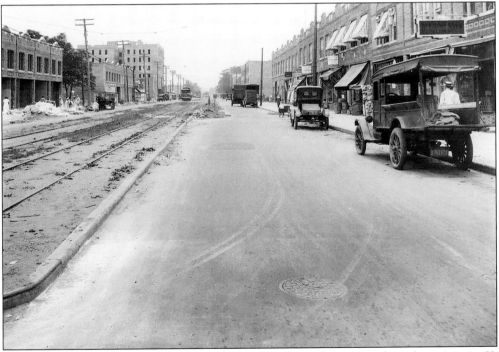

Pictured above is Coney Island Avenue looking north on the east roadway from Avenue K. Coney Island Avenue was opened originally as a main thoroughfare to Coney Island in 1850 and widened in 1872. It originally contained wooden planks. This photograph was taken on July 10, 1924.

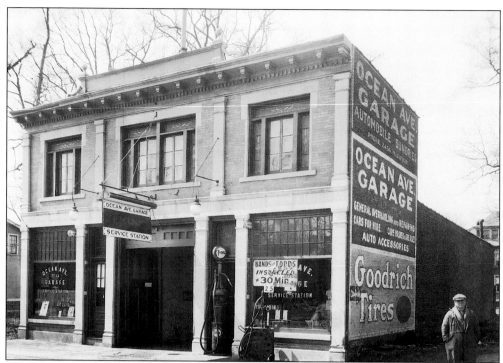

In this March 21, 1925 image of 2044 Ocean Avenue Garage, the north side and front of the garage, located between Avenues 0. and P., can be seen. Ocean Avenue was opened as a main road to Sheepshead Bay in 1876.

Pictured here is Kings Highway looking east from Ocean Avenue. The highway was an aboriginal path that is believed to be over ten thousand years old. During the Colonial period, it was named after King George III of England. This image was taken on October 2, 1923.

106

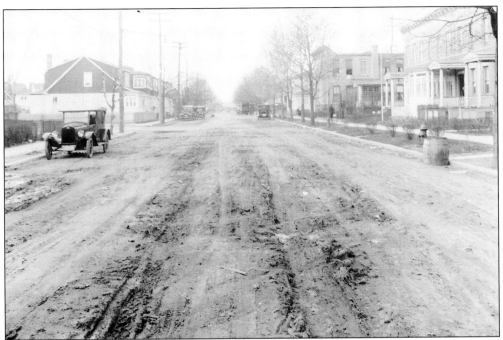

Above is Dahill Road looking north from #1034 between 21st Avenue and Avenue J. on April 19, 1924.

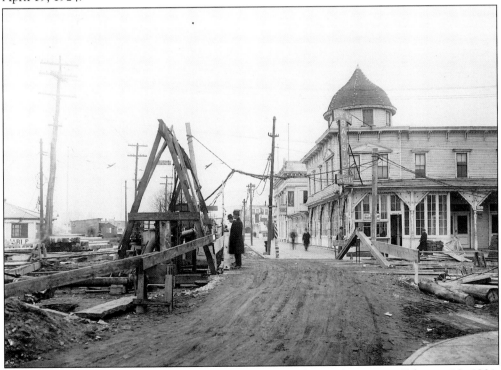

This is a view of Emmons Avenue looking west across Ocean Avenue on February 10, 1921. The Bayside Hotel on the corner would later be torn down to make way for the new Lundy's Restaurant in Sheepshead Bay.

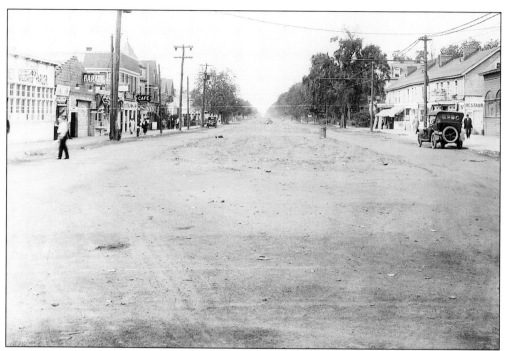

Above is Ocean Avenue looking north from Emmons Avenue to Voorhies Avenue in Sheepshead Bay on September 16, 1921. The Belt Parkway was not built when this photograph was taken.

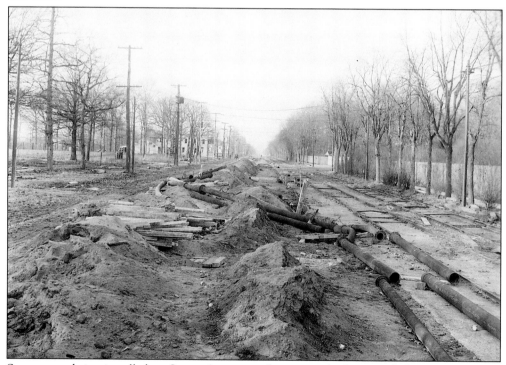

Sewers were being installed on Ocean Avenue in this section looking north from Avenue Y. to Avenue X. on January 20, 1921, in Sheepshead Bay.

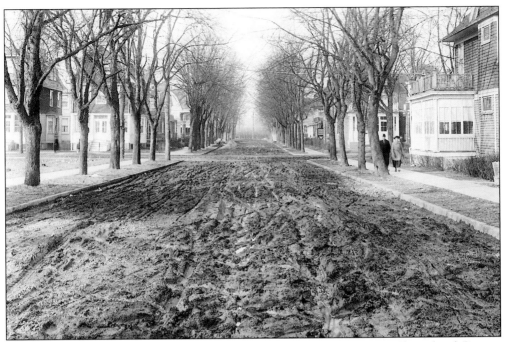

Above is East 21st Street looking north towards Voorhies Avenue in Sheepshead Bay on February 22, 1922.

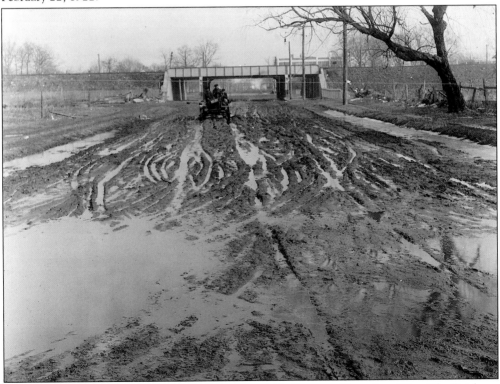

Pictured here is Avenue Y. looking east from East 14th Street in Sheepshead Bay. The Brighton Line is in the rear at East 15th Street. This image was taken on February 22, 1922.

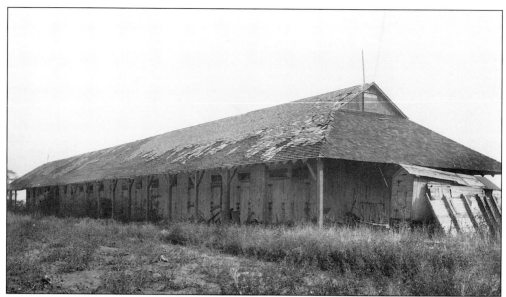

The northeast corner of Avenue Y. and Batchelder Street shows the remaining stables from the old Coney Island Jockey Club in Sheepshead Bay which closed in 1910. This photograph was taken on October 19, 1929.

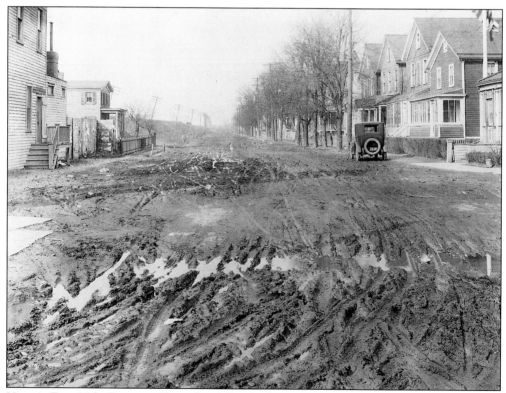

Here is East 16th Street in Sheepshead Bay looking north from Sheepshead Bay Road on February 22, 1922.

Here is East 15th Street in Sheepshead Bay looking north from Avenue X. on May 26, 1924.

Above is East 18th Street looking north from Voorhies Avenue towards Jerome Avenue in Sheepshead Bay. This image was taken on November 25, 1924.

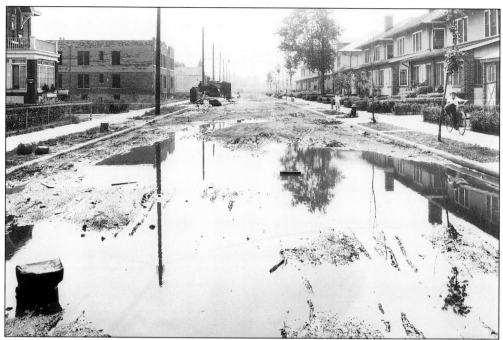

This is a view of Bay 37th Street in Bensonhurst looking south from Benson to Bath Avenues on August 28, 1924.

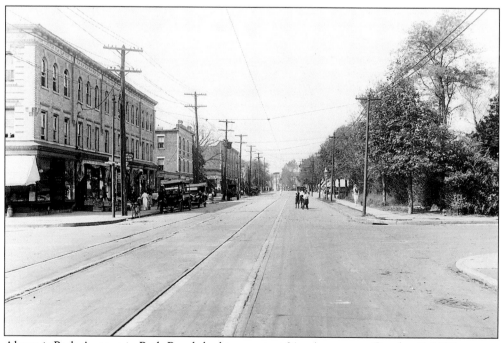

Above is Bath Avenue in Bath Beach looking west at 21st Avenue on October 2, 1921.

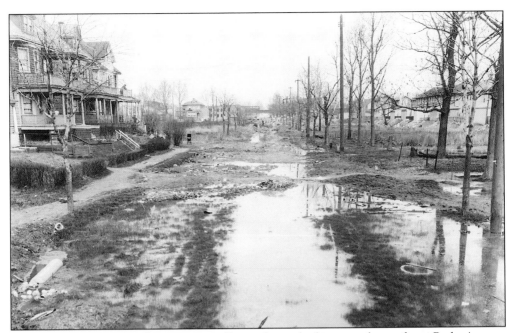

Pictured is Twenty-fourth Avenue in Bensonhurst looking northeast from Bath Avenue to Benson Avenue. The West End Elevated Line can be seen in the distance in this April 19, 1924 image.

Here is Eighty-fourth Street in Bensonhurst looking west from Bay Parkway on August 28, 1924.

Above is Seventy-ninth Street looking west from Stillwell Avenue towards 23rd Avenue on September 5, 1924.

New homes are being sold on 76th Street, looking west from Bay Parkway in Bensonhurst, on August 29, 1924.

This is the proposed park site bounded by 65th Street, Dahill Road, and Avenue P. on March 14, 1924. Gravesend (McDonald) Avenue can be seen to the left.

Above is West 10th Street looking north from Avenue S. on May 23, 1924.

Pictured above is Avenue P. looking west from Gravesend (McDonald) Avenue on December 31, 1924. The newly built public school 177, the Marlboro School, stands proudly facing Avenue P.

This view is of East 10th Street looking south from Avenue M. near the old Vitagraph Movie Studios on April 19, 1924.

Above is Avenue J. looking east from East 16th Street in the Midwood section on June 6, 1929.

Pictured is East 12th Street looking north from Avenue M. to Locust Avenue near the old Vitagraph Movie Studios on May 26, 1924.

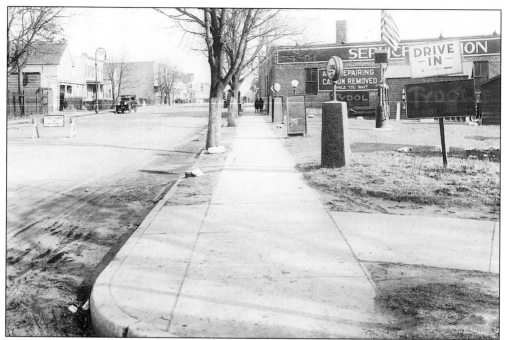

Heavy traffic was prohibited on Foster Avenue. This view is looking east from Ocean Parkway in the Parkville section, the northern section of the former Town of Gravesend, on January 7, 1922.

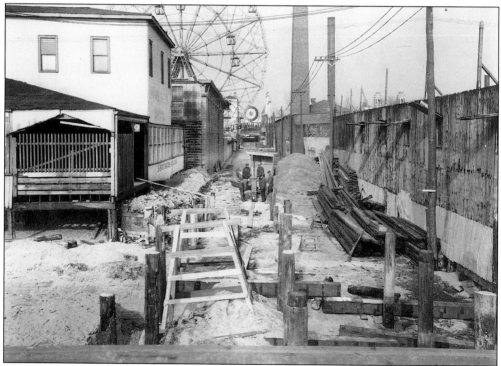

Above is Jones Walk in Coney Island looking from the Boardwalk to Surf Avenue on December 19, 1922.

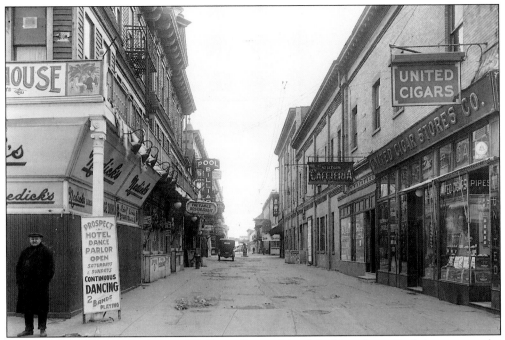

Above is a view of Hendersons Walk in Coney Island looking from Surf Avenue to the Boardwalk on December 19, 1922.

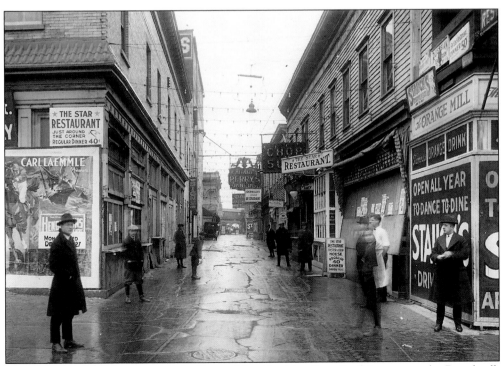

Here is a view of Strattons Walk in Coney Island looking from Surf Avenue to the Boardwalk on December 19, 1922. The Star Restaurant offered a regular dinner for 40¢.

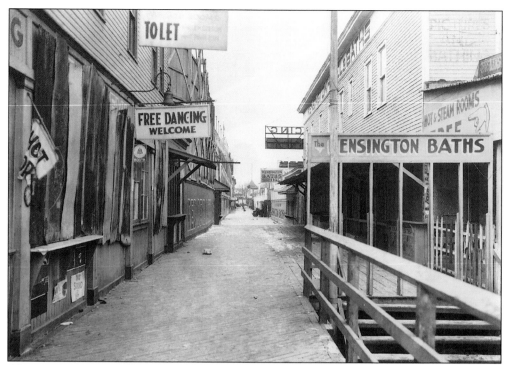

Above is Murrays Walk in Coney Island looking from the Boardwalk to Surf Avenue on December 19, 1922.

Three sisters of St. Joseph relax at the beach in this June 7, 1923 image, looking west at Jetty #5 at West 28th Street.

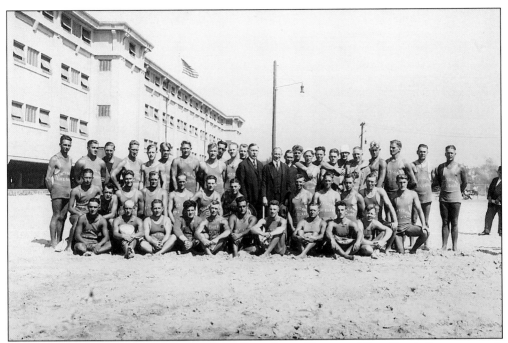

Borough President Riegelmann, along with Supt. James Byrne and Sec. Frank Fogarty, stands proudly with the Coney Island Lifeguards on September 13, 1922.

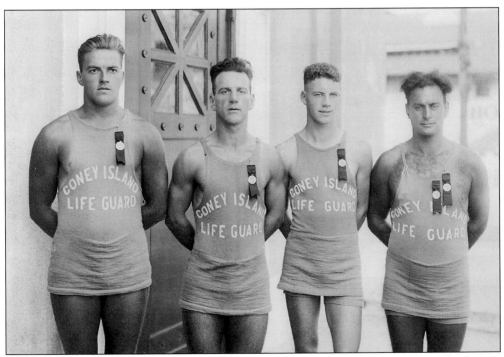

The winners of the September 19, 1922 One-Mile Relay Race at Coney Island were lifeguards. Listed from left to right, are as follows: A.J. Nicol, H. Montevelian, W. Dowd, and J.W. Frigenti.

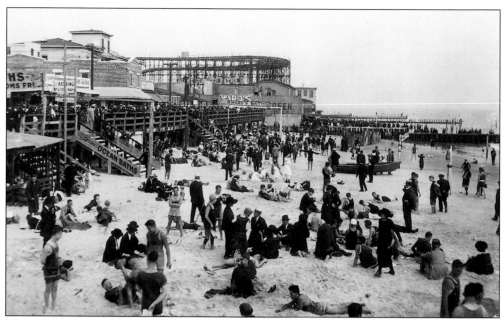

This is the Coney Island Beach front at Stauch's and Ward's Baths prior to the construction of the boardwalk. This image was taken on September 1, 1919.

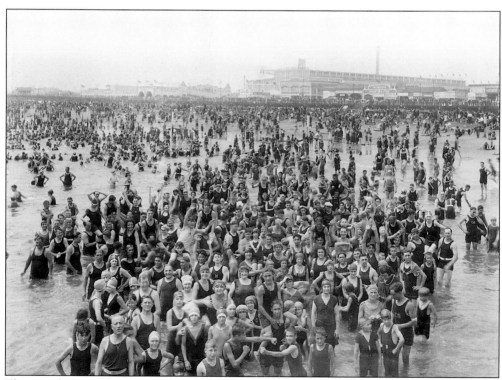

The crowds enjoy the waters of Coney Island. This view is looking northwest from Jetty #11 near Stillwell Avenue on Sunday, August 12, 1923. Steeplechase Park can be seen in the rear.

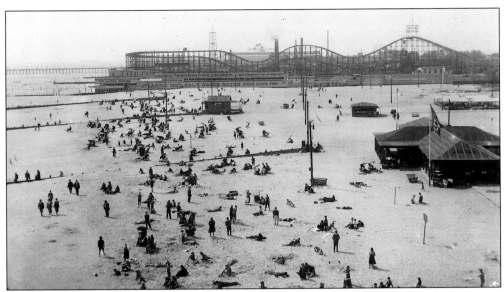

This view of the Coney Island Beach, prior to the building of the boardwalk, is looking west from the Municipal Bath on September 8, 1919.

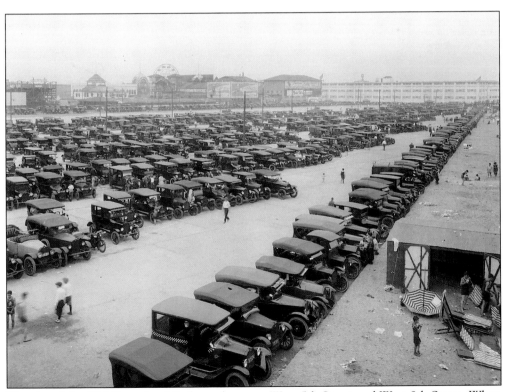

The site of the Old Dreamland Park was between West 5th Street and West 8th Street. When this photograph was taken on Sunday, August 5, 1923, this area served as the Municipal Parking Lot. Today it is the site of the New York Aquarium.

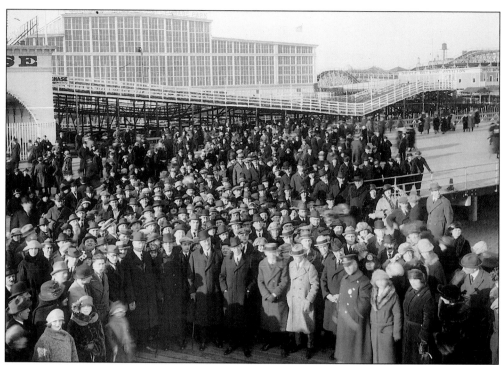

Mayor John F. Hylan and Borough Pres. Edward Riegelmann visit the Coney Island Boardwalk at Steeplechase Pier on March 13, 1923.

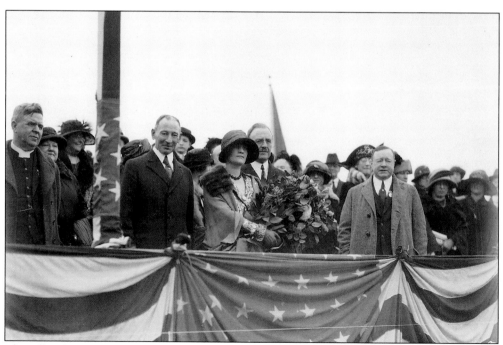

The official opening of the Coney Island Boardwalk on May 15, 1923, found many notables reviewing the parade. Listed from left to right, are the following: Reverend Cadman, Borough President Riegelmann, Miss Adele McCooey, Mayor Hylan, and Commissioner Guider.

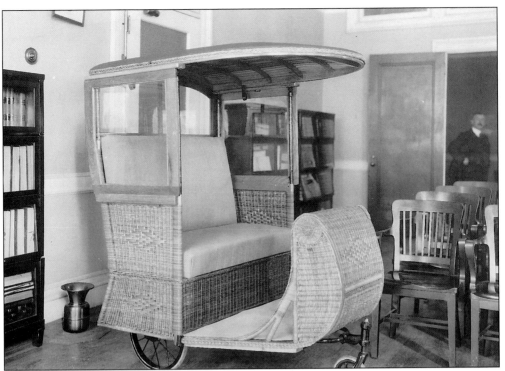

The proposed rolling chair for the Coney Island Boardwalk is exhibited at Borough Hall on March 21, 1924.

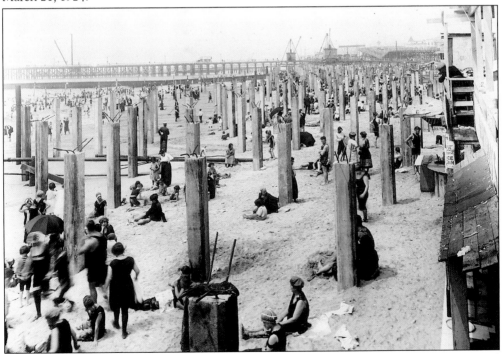

The people still came to the beach during the construction of the boardwalk. This is a general view looking west from Martino's Bath on July 21, 1922.

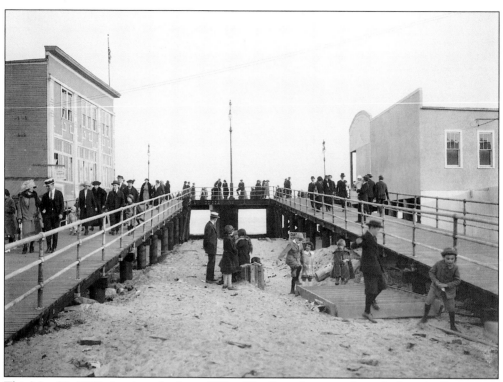

This May 20, 1923 view is at the foot of West 21st Street's approach to the boardwalk.

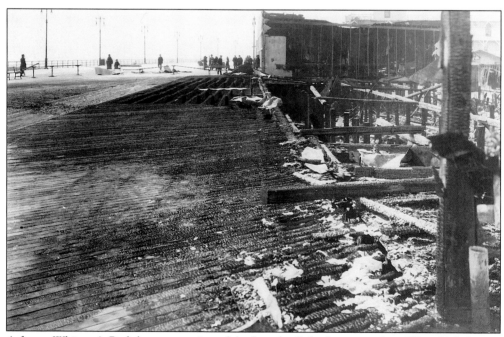

A fire at Whitney's Bath burnt a section of the boardwalk looking west from West 29th Street. This image was taken on April 4, 1924.

This is Sea Gate looking west from Beach 43rd Street across filled-in ground inside breakwater towards the lighthouse. This image was taken on November 5, 1920.

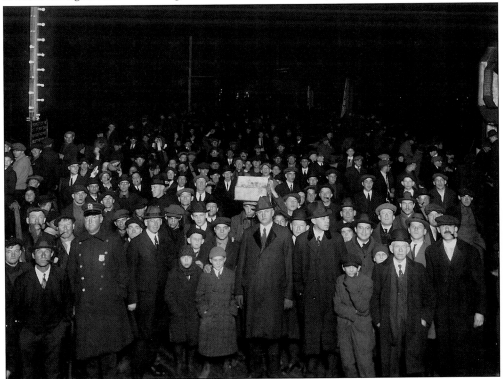

Borough President Riegelmann, along with other officials, makes a night visit to the Coney Island Pier to watch the fishermen on November 19, 1921.

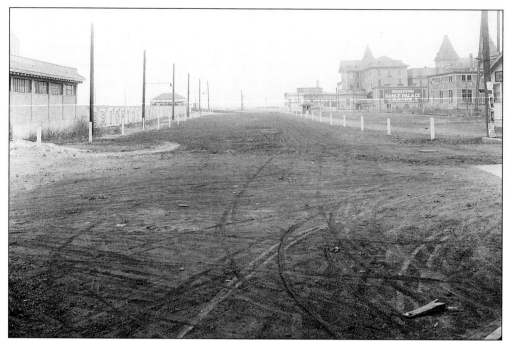

Pictured above is Coney Island Avenue looking south from Brighton Beach Avenue to the ocean. The Brighton Beach Hotel (to the right) would soon be demolished. This image was taken on March 23, 1923.

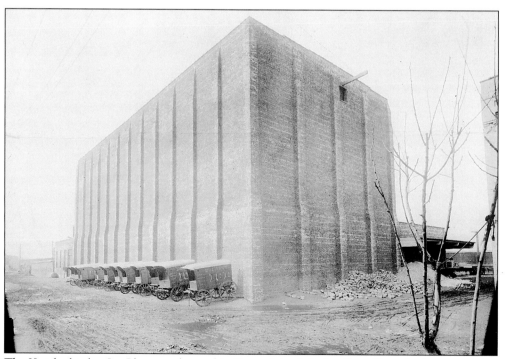

The Knickerbocker Ice Plant was located in Coney Island, facing Hart Place, looking west near the Coney Island Creek. This photograph was taken on February 16, 1918.